Put any picture you want on any state book cover. Makes a great gift. Go to www.america24-7.com/customcover

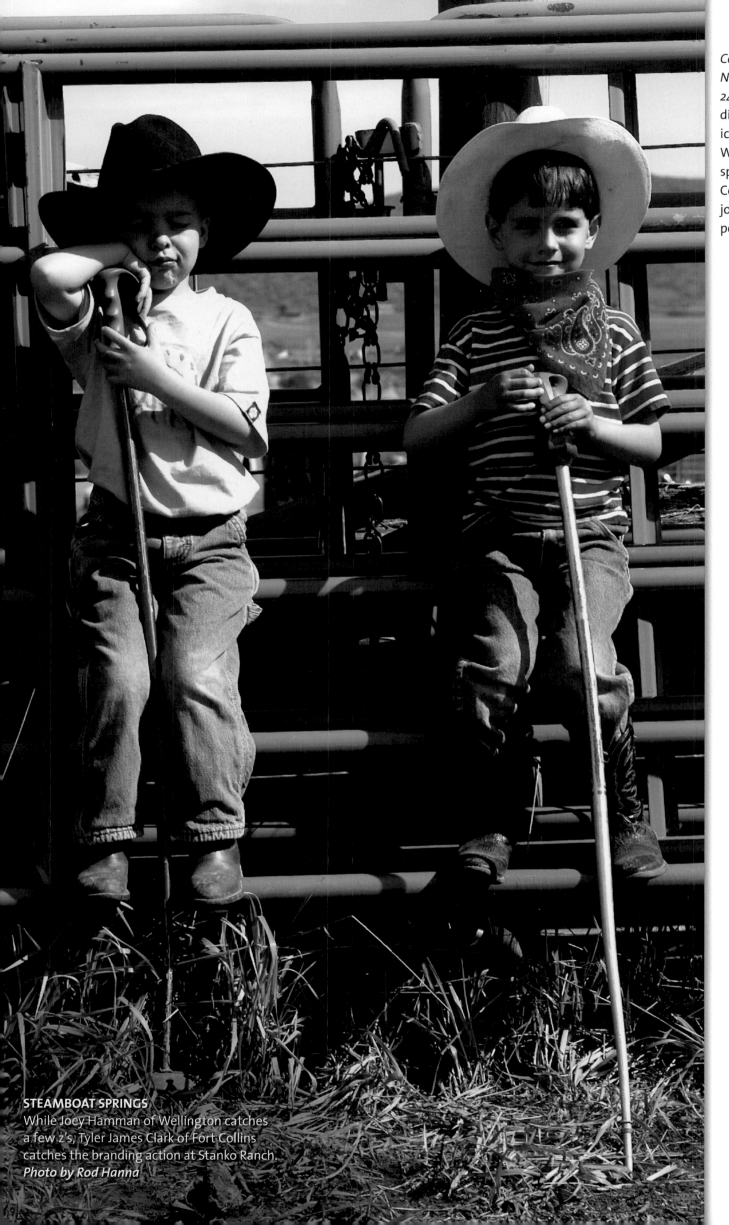

STEAMBOAT SPRINGS
While Joey Hamman of Wellington catches
a few z's, Tyler James Clark of Fort Collins
catches the branding action at Stanko Ranch.
Photo by Rod Hanna

Colorado 24/7 is the sequel to *The New York Times* bestseller *America 24/7* shot by tens of thousands of digital photographers across America over the course of a single week. We would like to thank the following sponsors, the wonderful people of Colorado, and the talented photo-journalists who made this book possible.

LONDON, NEW YORK, MUNICH, MELBOURNE, and DELHI

Created by Rick Smolan and David Elliot Cohen

24/7 Media, LLC
PO Box 1189
Sausalito, CA 94966-1189
www.america24-7.com

First Edition, 2004
04 05 06 07 08 10 9 8 7 6 5 4 3 2 1

Published in the United States by
DK Publishing, Inc.
375 Hudson Street
New York, NY 10014

DK Publishing, Inc. offers special discounts for bulk purchases for sales promo-
tions or premiums. Specific, large-quantity needs can be met with special
editions, personalized covers, excerpts of existing guides, and corporate
imprints. For more information, contact:

Special Markets Department
DK Publishing, Inc.
375 Hudson Street
New York, NY 10014
Fax: 212-689-5254

Cataloging-in-Publication data is available
from the Library of Congress
ISBN 0-7566-0045-6

Printed in the UK by Butler & Tanner Limited

First printing. October 2004

EL PASO COUNTY
Cowboys and contrails: El Paso County
ranchers take the time to help each other
out during the month-long spring branding
season. Jim Hicks, Maggie Hanna, Pat Poer,
and Dick Tanner get ready to handle about
250 calves at Jay Frost's ranch.
Photo by Mark Reis,
The Colorado Springs Gazette

COLORADO 24/7

24 Hours. 7 Days.
Extraordinary Images of
One Week in Colorado.

Created by Rick Smolan and David Elliot Cohen

DK Publishing

About the America 24/7 Project

A hundred years hence, historians may pose questions such as: What was America like at the beginning of the third millennium? How did life change after 9/11 and the ensuing war on terrorism? How was America affected by its corporate scandals and the high-tech boom and bust? Could Americans still express themselves freely?

To address these questions, we created *America 24/7*, the largest collaborative photography event in history. We invited Americans to tell their stories with digital pictures. We asked them to shoot a visual memoir of their lives, families, and communities.

During one week in May 2003, more than 25,000 professionals and amateurs shot more than a million pictures. These images, sent to us via the Internet, compose a panoramic yet highly intimate view of Americans in celebration and sadness; in action and contemplation; at work, home, and school. The best of these photographs, more than 6,000, are collected in 51 volumes that make up the *America 24/7* series: the landmark national volume *America 24/7*, published to critical acclaim in 2003, and the 50 state books published in 2004.

Our decision to make *America 24/7* an all-digital project was prompted by the fact that in 2003 digital camera sales overtook film camera sales. This techno-logical evolution allowed us to extend the project to a huge pool of photographers. We were thrilled by the response to our challenge and moved by the insight offered into American life. Sometimes, the amateurs outshot the pros—even the Pulitzer Prize winners.

The exuberant democracy of images visible throughout these books is a revela-tion. The message that emerges is that now, more than ever, America is a supersized idea. A dreamspace, where individuals and families from around the world are free to govern themselves, worship, read, and speak as they wish. Within its wide margins, the polyglot American nation manages to encompass an inexplicably complex yet workable whole. The pictures in this book are dedicated to that idea.

—*Rick Smolan and David Elliot Cohen*

American nightlight: More than a quarter of a billion people trace a nation with incandescence in this composite satellite photograph.
Photo by Craig Mayhew & Robert Simmon, NASA Goddard Flight Center/Visions of Tomorrow

A State of Mountains

By Peter G. Chronis

Denver native and noted poet Thomas Hornsby Ferril regularly used to warn other writers against "god-finding" when they went into the Colorado Rockies, but usually to no avail. Even today, the grandeur of our mountains inspires some god-awful purple prose.

But the Rockies are irrefutable. The ramparts, peaks, and valleys dominate the landscape and shape the story of Colorado, from the first Native Americans eons ago, to the arrival of land grant settlers from Spain and Mexico in the San Luis Valley in the early 19th century, to the fortune-seekers of the Pikes Peak Gold Rush of 1858.

Wherever there was tillable land, homesteaders staked out farms. Immigrants from Europe and Mexico built railroads and worked the coal mines. When Denver was still a wild frontier town, civic leaders realized they needed rail service to remain viable. So, in 1870, Denverites paid for a rail connection with the Union Pacific's transcontinental mainline at Cheyenne, Wyoming. Statehood arrived in 1876—and the state had a nickname: the Centennial State.

Gold and silver were okay for making overnight "cities" and overnight millionaires, but Colorado needed people to settle in for the long haul. It needed an economy less vulnerable to boom-and-bust cycles. Settlers carved sheep and cattle ranches out of the rugged country, and Denver with its rail yards became a cattle town. Industries sprouted all along the Rocky Mountains' Front Range. Colleges sprang up to turn out teachers, doctors, lawyers, and engineers.

World War II brought the defense industry and tens of thousands of GIs to Colorado for training as air crew members, foot soldiers, and ski troops. Veterans of the 10th Mountain Division who had trained here launched the state's ski industry. There are now 24 ski resorts in the mountains. Droves of veterans fell in love with the place and moved here after the war. More recent arrivals include refugees from wars in Asia and poverty in Latin America. Always growing, always adding to the mural that is Colorado.

There are now more than 4.3 million of us: 83 percent Caucasian, 17 percent Latino, 4 percent African American, 2.2 percent Asian, and 1 percent Native American. Growth has continued almost unabated—the beauty and variety of the terrain may be partly to blame for that. Some even grouse that Colorado's gotten too crowded.

New industries (and the short-lived oil boom of the early 1980s) brought waves of new residents and new ideas to a basically conservative state where people cling to western habits like a gun or two at home, a healthy skepticism about government, and a tendency to mind their own business. Politics range from lefty-liberal to far-right Christian fundamentalist. Maybe that's why Colorado political campaigns are never dull.

Argue? You bet! Coloradans can be as unyielding as granite. We get it from the mountains.

PETER G. CHRONIS *is an editorial writer for* The Denver Post *and lives with his wife and son in Denver.*

ERIE

Two crew members keep the folds of the fabric straight while their hot air balloon is inflated at the Erie Town Fair. A bevy of balloons launches at sunrise to kick off the annual event.

Photo by Barry Gutierrez,
Rocky Mountain News

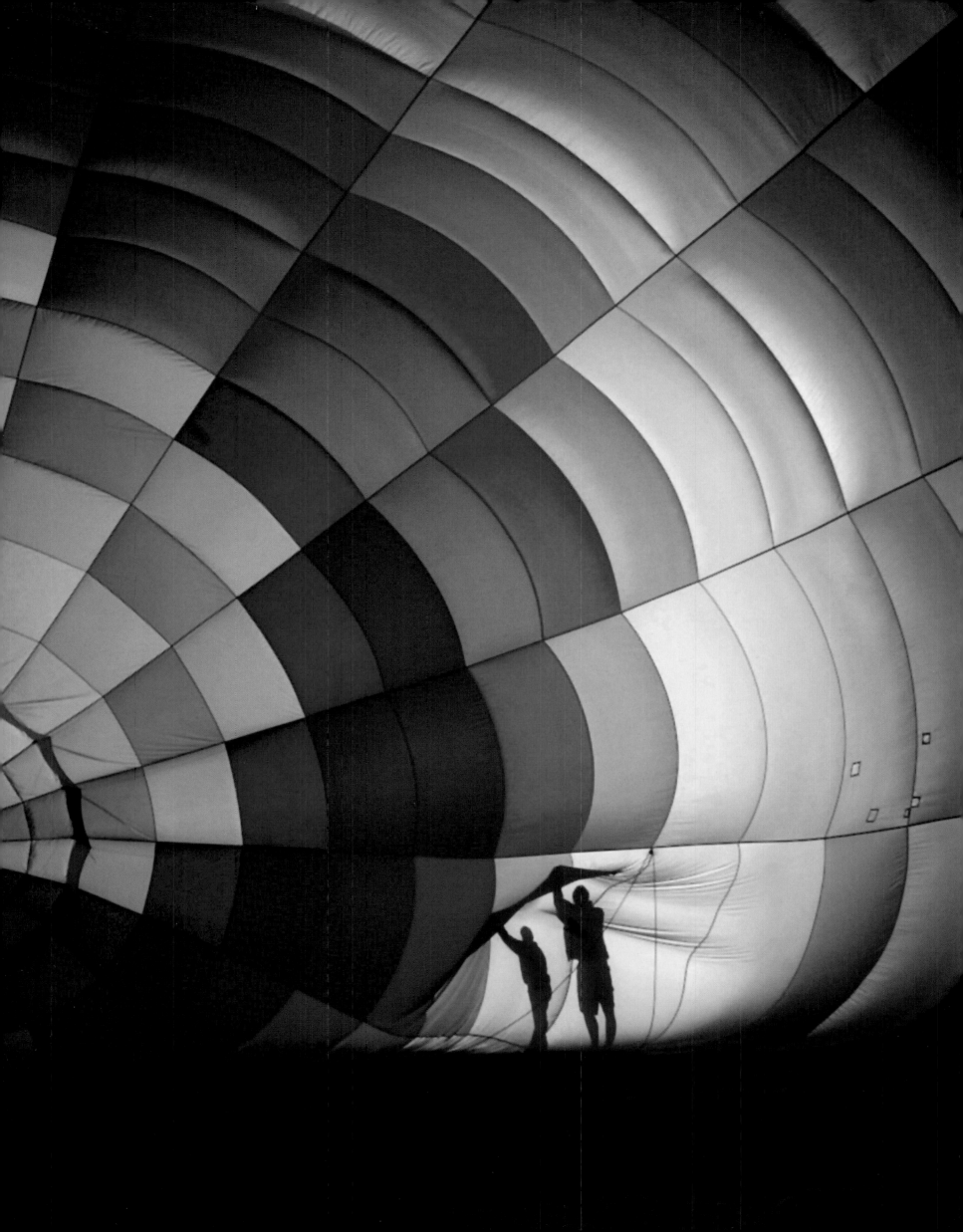

ROCKY MOUNTAIN NATIONAL PARK
U.S. Park Ranger Leanne Benton checks snow
levels at Rock Cut. This section of Trail Ridge
Road is the highest continuous paved road in
America, with eight miles above 11,000 feet
and a maximum elevation of 12,183 feet. Four-
person snow removal crews have been work-
ing continuously for two weeks to open the
road by Memorial Day.
Photo by Glenn J. Asakawa, The Denver Post

ASPEN

Aspen Highlands peak (12,302 feet) looms in the background, partially obscured by clouds swirling above the ski runs on Buttermilk's Tiehack Mountain. Both are part of the huge Aspen/Snowmass ski resort. The lifts at Buttermilk opened in 1958 with a $3 lift ticket price; today, a one-day lift ticket will set you back $72.

Photo by Robert Millman

BOULDER
At the end of most workdays Joseph Calitri and Wendy Woods "chill out, unwind, and detox," as he says, on the living room couch. He has his own housecleaning business; she is a psychology student at Naropa Institute.
Photo by Emily Yates-Doerr

Hearth & Home

BERTHOUD
Twenty-one years ago, Larry and Jackie Bebo began adopting children even though they had two of their own. "It just seemed like the right thing to do," says Jackie. Since then they have parented 26 kids from countries including Vietnam, China, Haiti, India, and America. The family lives in a roomy, 10,000-square-foot house on a 126-acre farm.
Photo by Glenn J. Asakawa, The Denver Post

BERTHOUD

Jackie Bebo reads *Hurricane Henrietta* to a handful of her adopted children before bedtime. The youngest child she and husband Larry have taken in was a newborn and the oldest, a 14-year-old Amerasian girl. "We'll never have an empty nest," says Larry, 56, who runs a contracting business.
Photos by Glenn J. Asakawa, The Denver Post

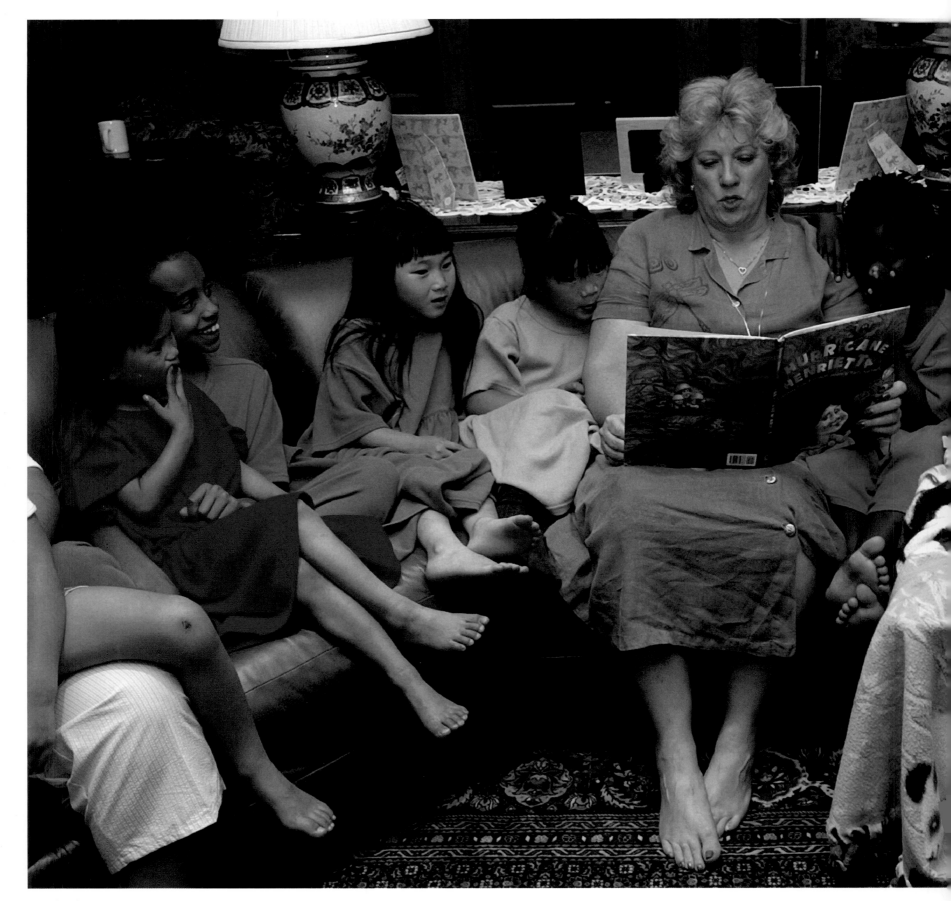

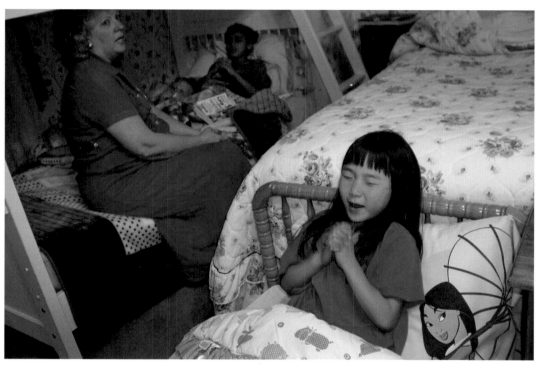

BERTHOUD

In one of the Bebo family's nine bedrooms, 5-year-old Saijin leads mom Jackie and sisters Emerson and Baylor in bedtime prayers. Nine children between the ages of 2 and 17 currently live in the house—at one time there were eighteen. "None of the adult kids strayed far," says Larry. "They're all within a 15-minute drive."

BERTHOUD

The big treat is sleeping with mom and dad in their huge bed. But conflicts do arise—hence the necessity of a rotating schedule. "We have bunk beds in the master bedroom," says Larry. "It's like a slumber party."

SLEEPS w/mom

monday = Genima

Tuesday = Saijin

Wendsday = Sanai

Thursday = Sophie

Friday = Baylor

SAT = NO ONE!!

SUN = NO ONE!!

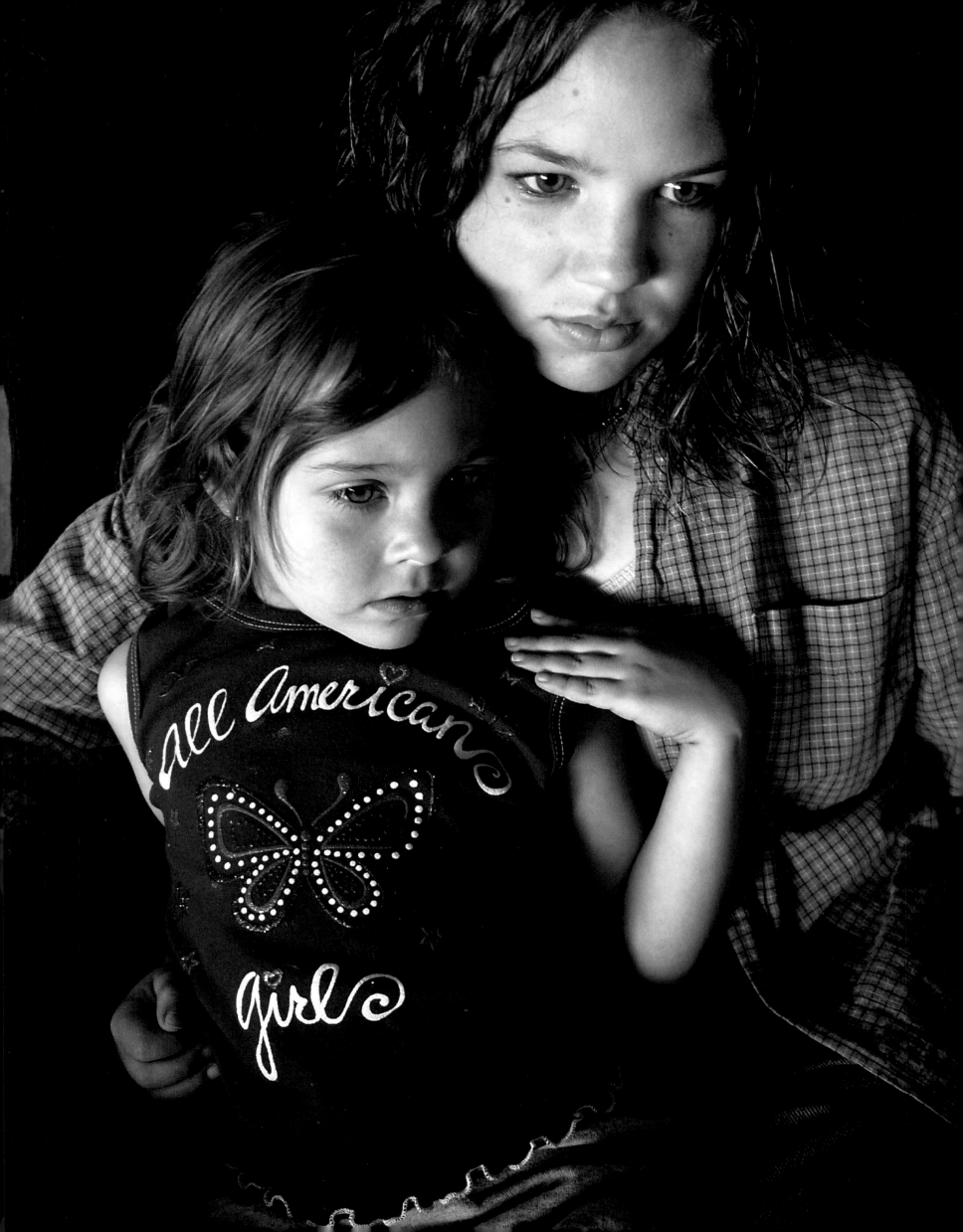

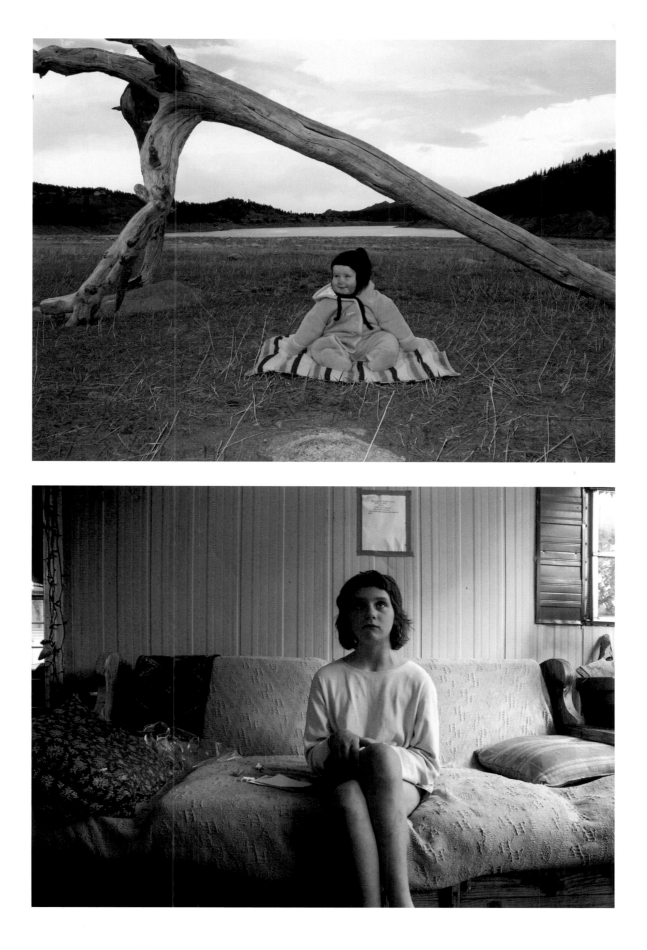

FOUNTAIN
High school sophomore Nicoal Fleming is close friends with Britni Jacques's baby-sitter. They all hang out together and watch TV. A soccer player, Nicoal says she loves watching professional soccer on ESPN.
Photo by Andrea Modica,
Marilyn Cadenboch Association

NEDERLAND
Maya Luna Hamilton sits in the parched Barker Reservoir.
Photo by Barbara Colombo,
11:11 Productions

BOULDER
Even though Randy Stadt, 11, was born with cerebral palsy, it has not slowed her down. She goes camping, rides on her father's motorcycle, and has a horse named Buddy. "Randy doesn't feel sorry for herself. She's got a great attitude," says her dad.
Photo by Emily Yates-Doerr

EAGLE
For tiara-wearing birthday girl Callie Bruckner, mom threw a buddy binge for a dozen girls from the Brush Creek Elementary School kindergarten. The day involves games, presents, cake, and movies—followed by a slumber party where everyone stays up as long as possible.
Photo by Emily Yates-Doerr

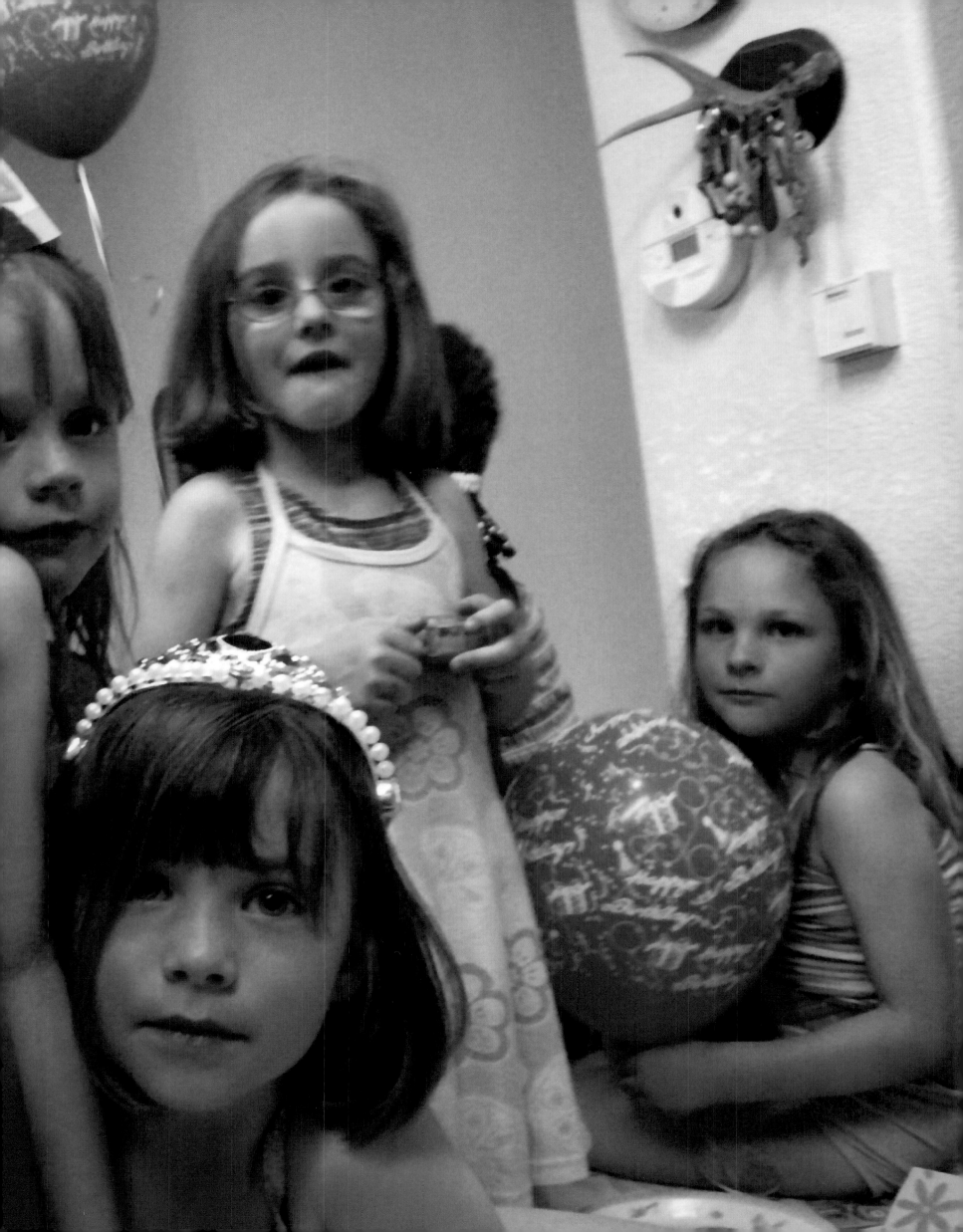

ENGLEWOOD

Lauribeth Gonzalez (left) freshens up before filming a segment for a video yearbook at Sinclair Middle School. Like other girls her age, the 14-year-old spends her allowance on lip gloss, eye-liner, and nail polish. American tweens and teens purchase close to $8 billion in health and beauty products annually.
Photo by Craig F. Walker,
The Denver Post

GOLDEN

Though Reade Warner isn't a licensed barber, he does have a gentle touch as he styles younger brother Tate's hair before they head off to day care.
Photo by Jeff R. Warner

GOLDEN

Egg-cited: Chef Reade Warner adds a little spice to a belated Mother's Day breakfast. His photographer dad was out of town that day, so the celebration took place the morning after.
Photo by Jeff R. Warner

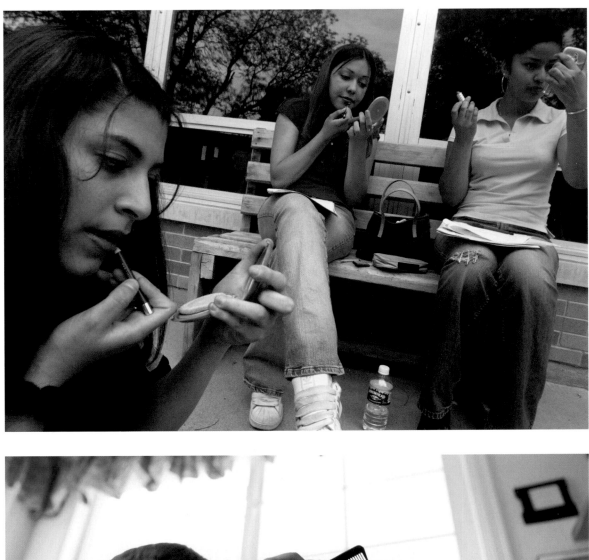

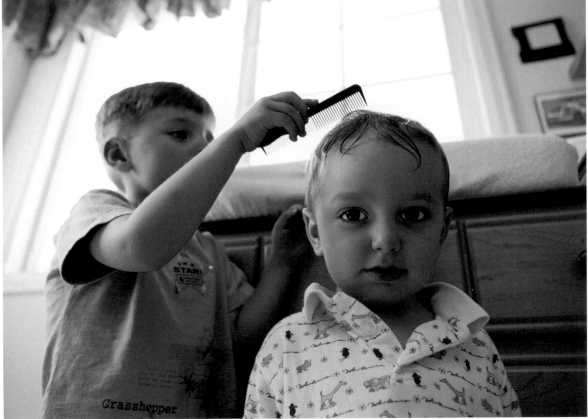

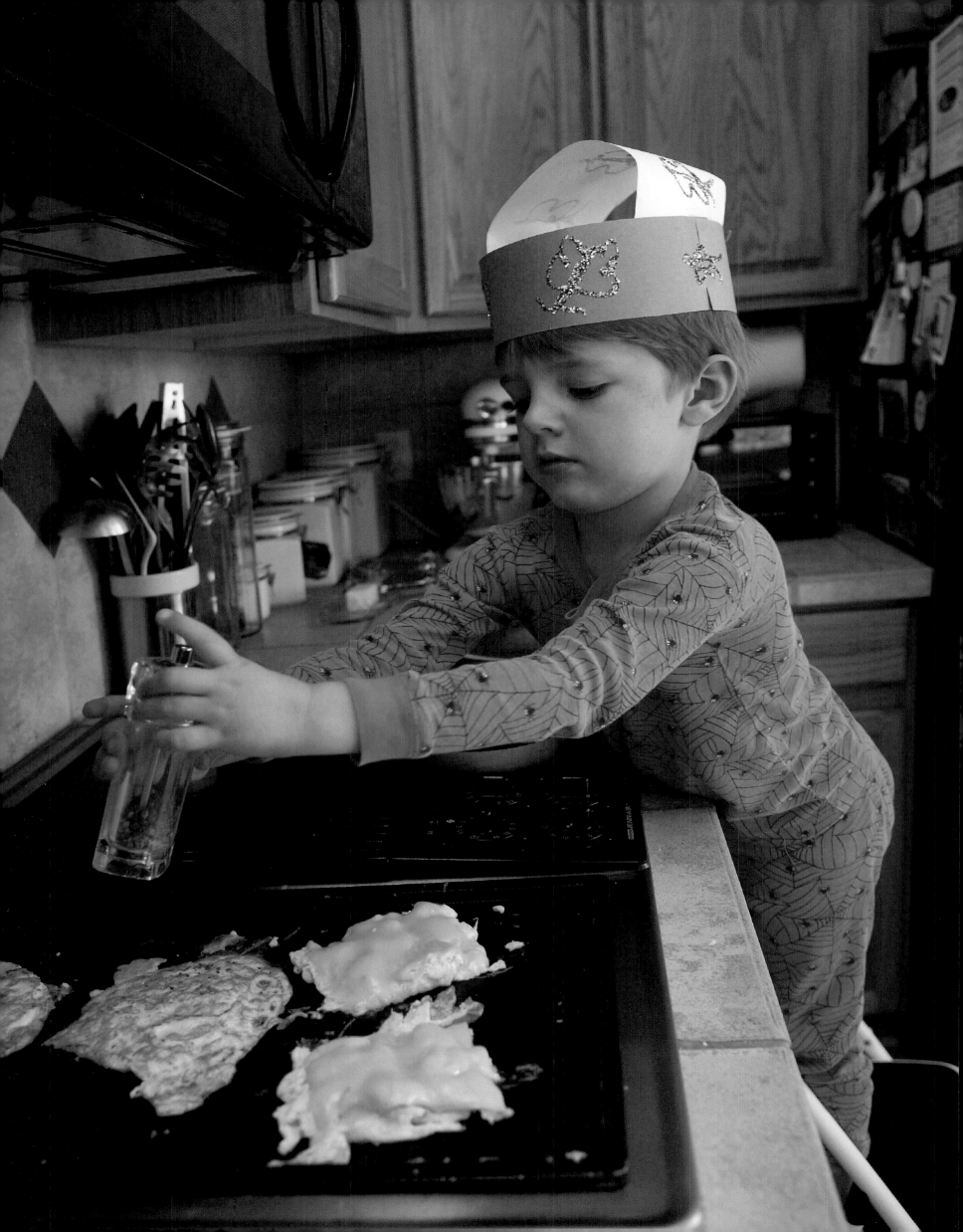

ENGLEWOOD

Don't call Elizabeth Albe's style Goth—the eighth grader doesn't like to be labeled. Her experience is unique, she says. The Sinclair Middle School student achieved near-perfect attendance and honor roll status at a time when her family of five was homeless and living out of their truck.
Photos by Craig F. Walker, The Denver Post

DENVER

John Tinsely left Tulsa, Oklahoma, six years ago after divorcing his wife. He has been rambling around the country aboard freight trains ever since but hopes to figure out a more permanent home for himself and 4-month-old Diesel soon. Denver and New York City are his top choices.

BOULDER

David Mejias rolled out of bed, set up his tripod and camera, and posed for this photo to depict single life at home. Then, he went to his job as president of Sonora Entertainment Group. The company operates three popular movie theaters (in Aurora, Fort Worth, and Phoenix) that show first-run U.S. films dubbed or subtitled in Spanish.
Photo by David Mejias

EAGLE

Gnome sweet gnome: Neighbors visit a garage sale in everyone's favorite small town. Originally home to Ute Indians, then miners and sheep-hercers, Eagle now busies itself with the tourism industry. The biggest employer in the area is the Vail ski resort, with 2,800 seasonal and 1,500 permanent employees.
Photo by Emily Yates-Doerr

EAGLE

Natalie Goodwin helps grandpa Ed Fetzer water the front yard. When the sun is out, they play a game she calls "Make a Rainbow." All it takes is a nozzle with fine spray and bright sunlight.
Photo by Emily Yates-Doerr

LOVELAND
America's favorite pastime draws locals to Barnes
Softball Park for a coed slow-pitch contest.
Photo by David Harrison

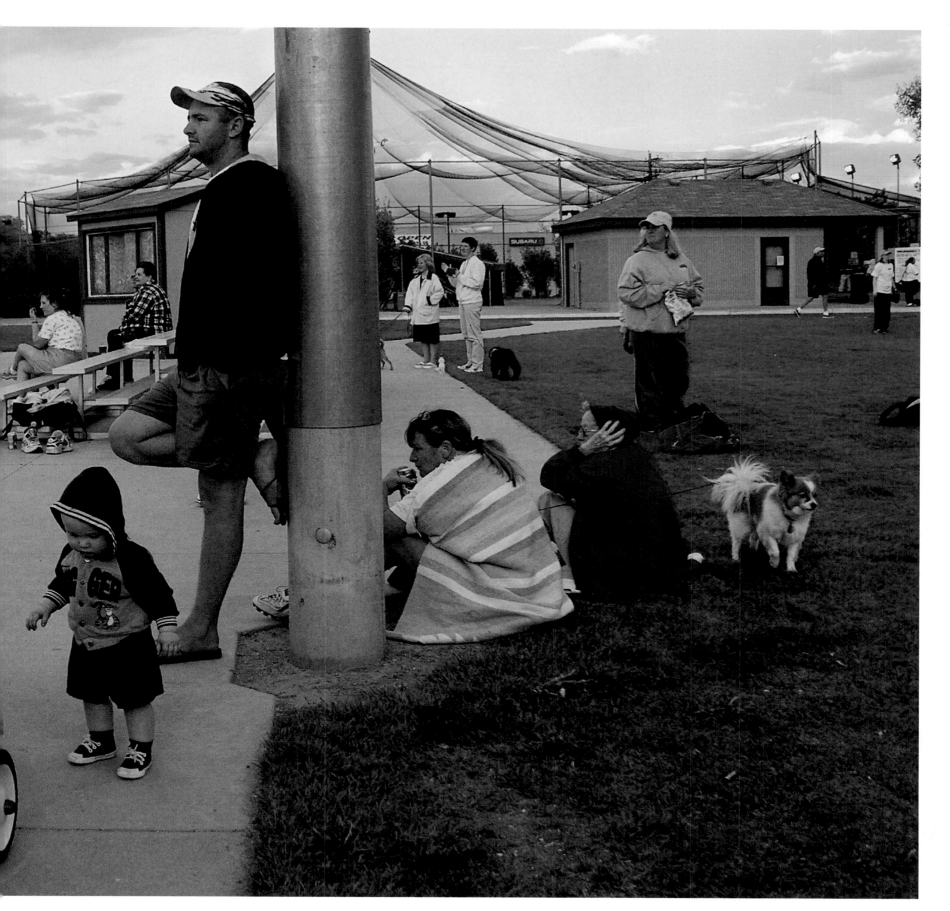

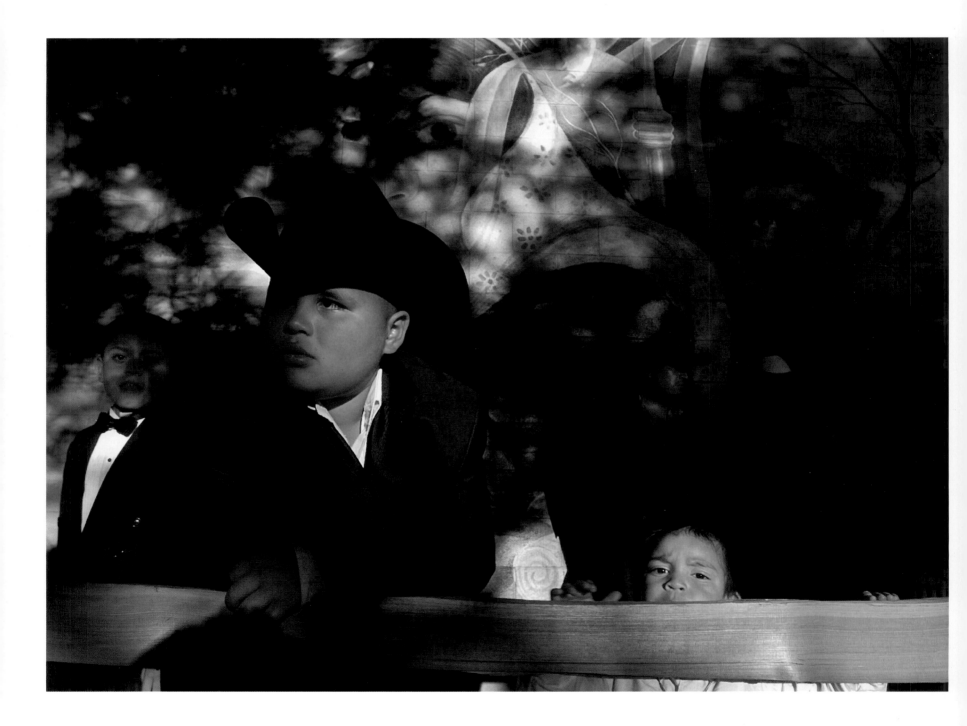

DENVER

Niños attending a wedding held at Our Lady of Guadalupe Church clock in some shade time in a courtyard outside the reception hall. Murals depicting Aztec traditions, Mexican folklore, and the United Farm Workers' struggle adorn the North Denver church, which has been a bastion of Chicano activism since the 1960s.

Photos by Todd Heisler, Rocky Mountain News

DENVER
Alma Garcia, 3, couldn't take another toast to the newlyweds, Adolfo and Eduvina Pinedo. Tickling the wedding party's feet was much more interesting.

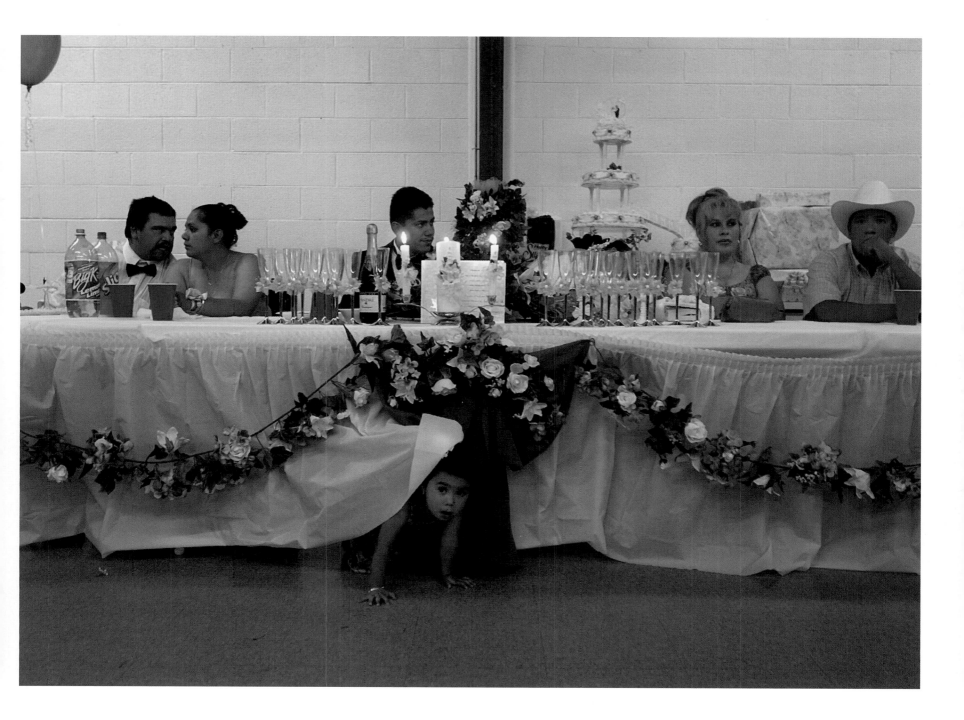

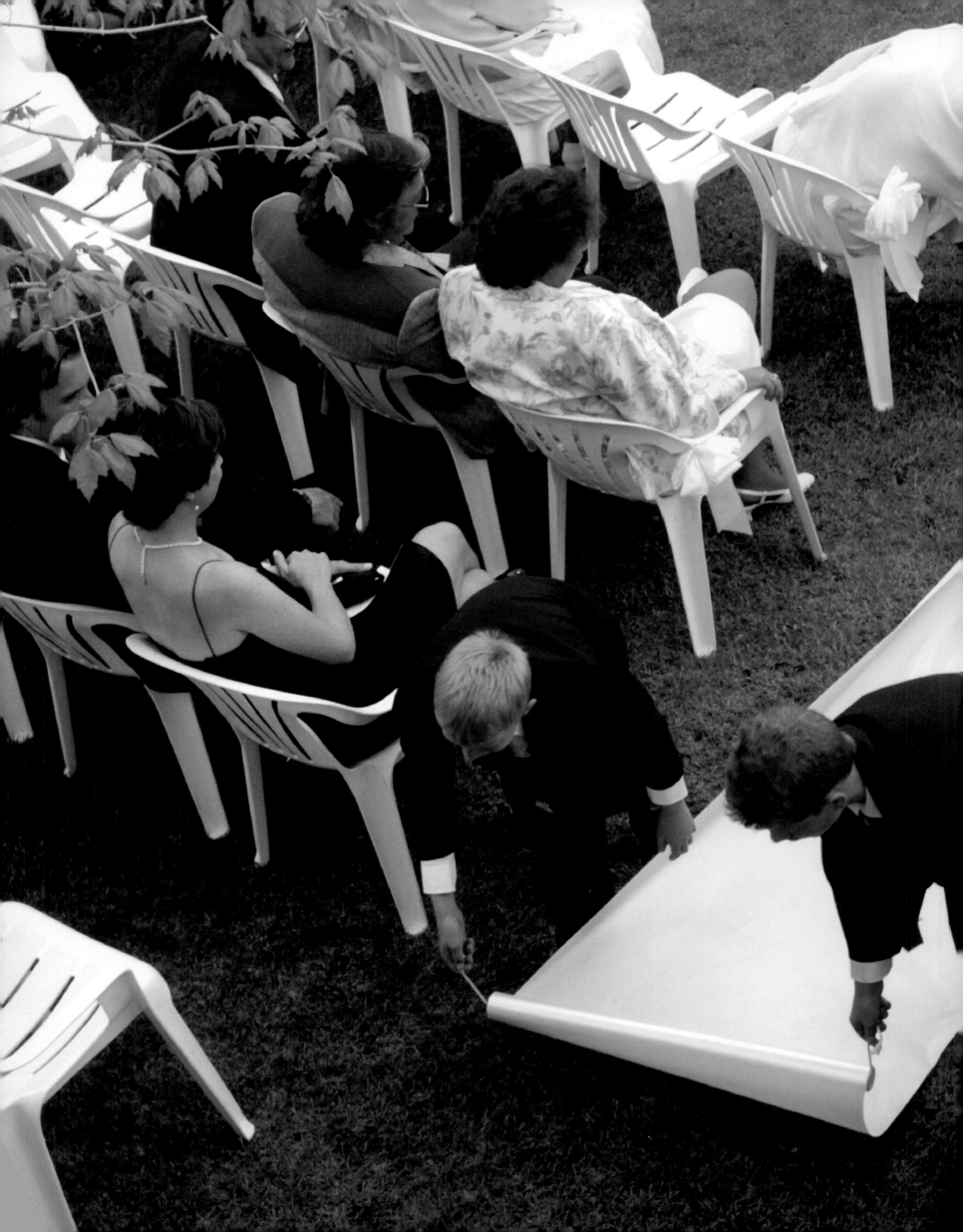

BOULDER
The mother of the bride smooths a wrinkle as ushers unfurl a silk walkway in preparation for Geri Brown and Doug Mitchell's grand entrance. In spite of all the meticulous planning, the couple's wedding, held at the Greenbrier Inn in the Boulder foothills, still had some uninvited guests: a swarm of butterflies and a wild rabbit.
Photo by Jacob Pritchard, Walkabout Studio

The year 2003 marked a turning point in the history of photography: It was the first year that digital cameras outsold film cameras. To celebrate this unprecedented sea change, the *America 24/7* project invited amateur photographers—along with students and professionals—to shoot and, via the Internet, submit digital images. Think of it as audience participation. Their visions of community are interspersed with the professional frames throughout this book. On the following four pages, however, we present a gallery produced exclusively by amateur photographers.

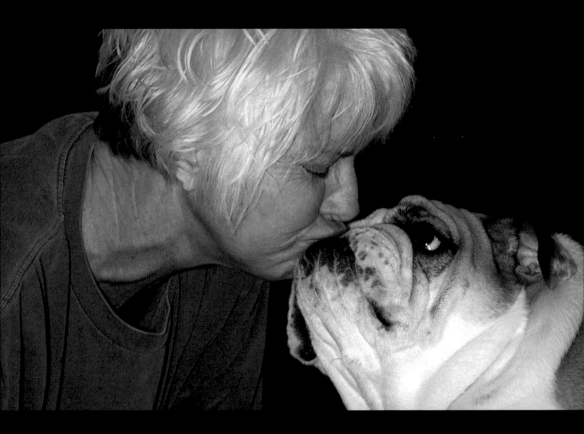

COLORADO SPRINGS Bulldog snog: Contessa plants a wet one on owner Mary Laswell. *Photo by Skip Mundy*

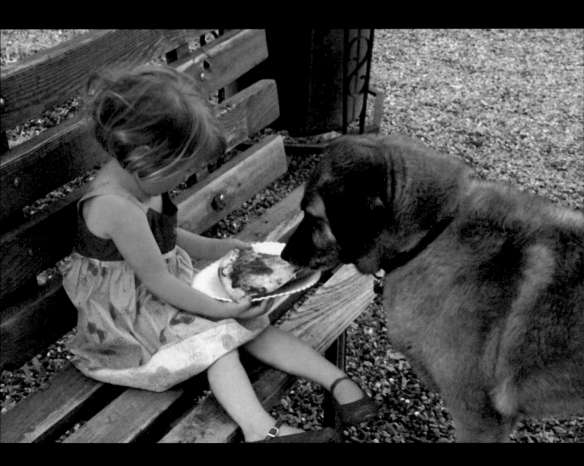

OLATHE Pepperoni Pizza Pals: Isabel Haga and Jasper make short work of their favorite lunch.

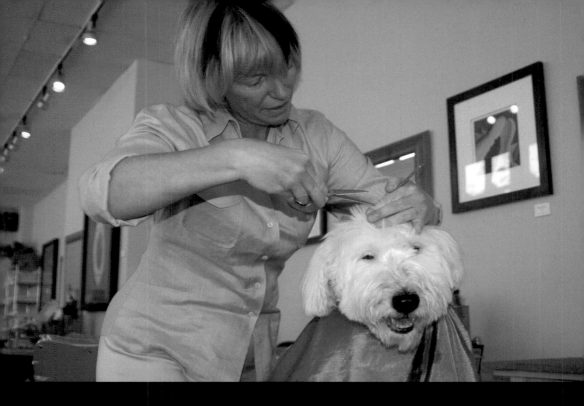

BOULDER Bisbee gets some beauty maintenance from his favorite stylist. Next stop: The nail salon. *Photo by Deborah Getchell*

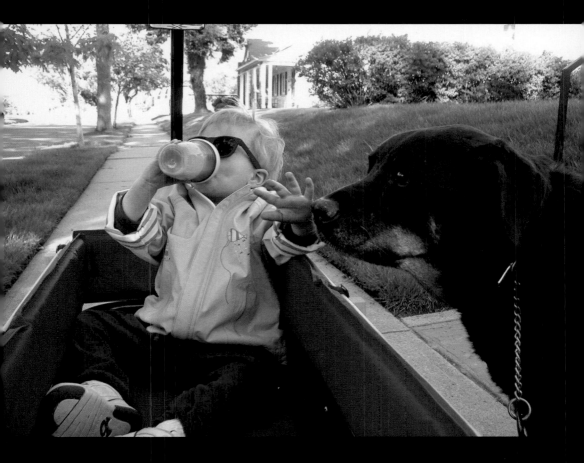

DENVER Not only has Colin McKinzie got milk, he's got his dog Dempsey and his mom, photographer Justine, who's pulling him through their Bonnie Brae neighborhood. *Photo by Justine McKinzie*

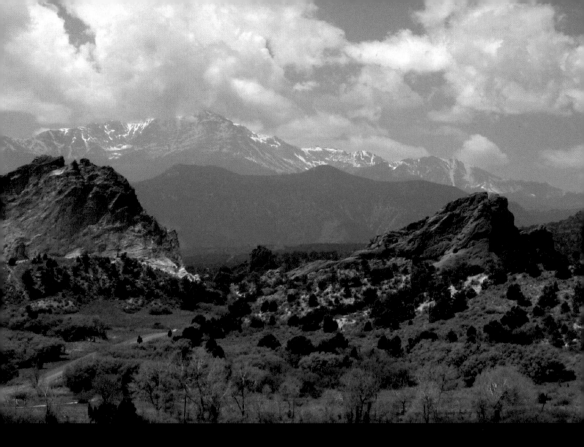

COLORADO SPRINGS Gateway to the Front Range. The Red Lions Formation in Garden of the Gods Park frames Pikes Peak (elevation 14,110 feet). *Photo by Ann Kaiser*

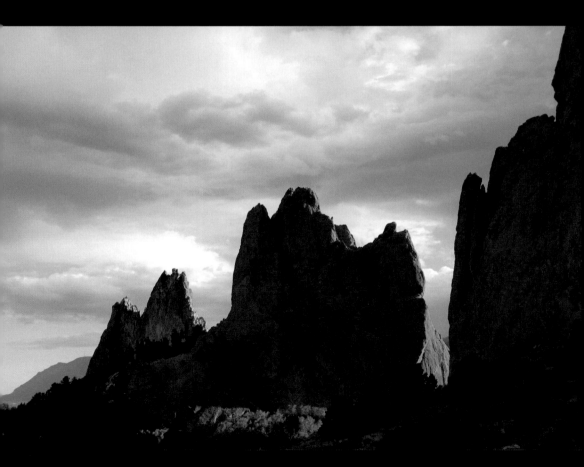

COLORADO SPRINGS These fins of sandstone rock in Garden of the Gods Park formed 60 million years ago, when two tectonic plates collided and forced great slabs of glacial sediment skyward. *Photo by Brian Fogarty*

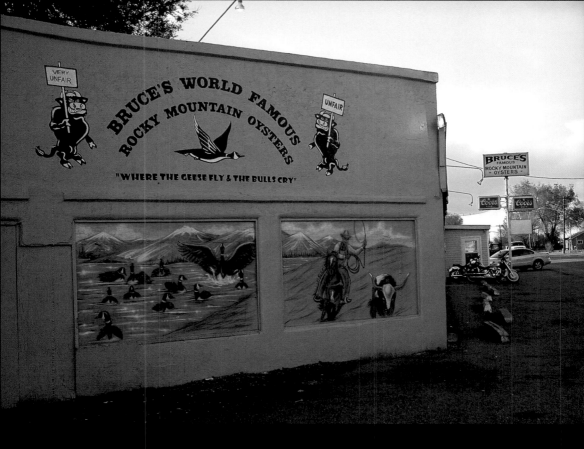

SEVERANCE Since 1957, Bruce's Bar has been serving up its world famous Rocky Mountain oysters in Severance, about 60 miles north of Denver. *Photo by Tracy Clark*

LASALLE It's a long view of the Front Range and Long's Peak—14,255 feet above sea level—from the outskirts of Greeley. *Photo by Tracy Clark*

EL PASO COUNTY

Ranch hands flank a calf during spring roundup at Jay Frost's ranch. More than 200 calves are branded, earmarked, dehorned, castrated, and vaccinated in twelve long hours. Sadly, that's just half of the usual herd; the 2002 drought forced Frost to sell 50 percent of his cattle.

Photo by Mark Reis,
The Colorado Springs Gazette

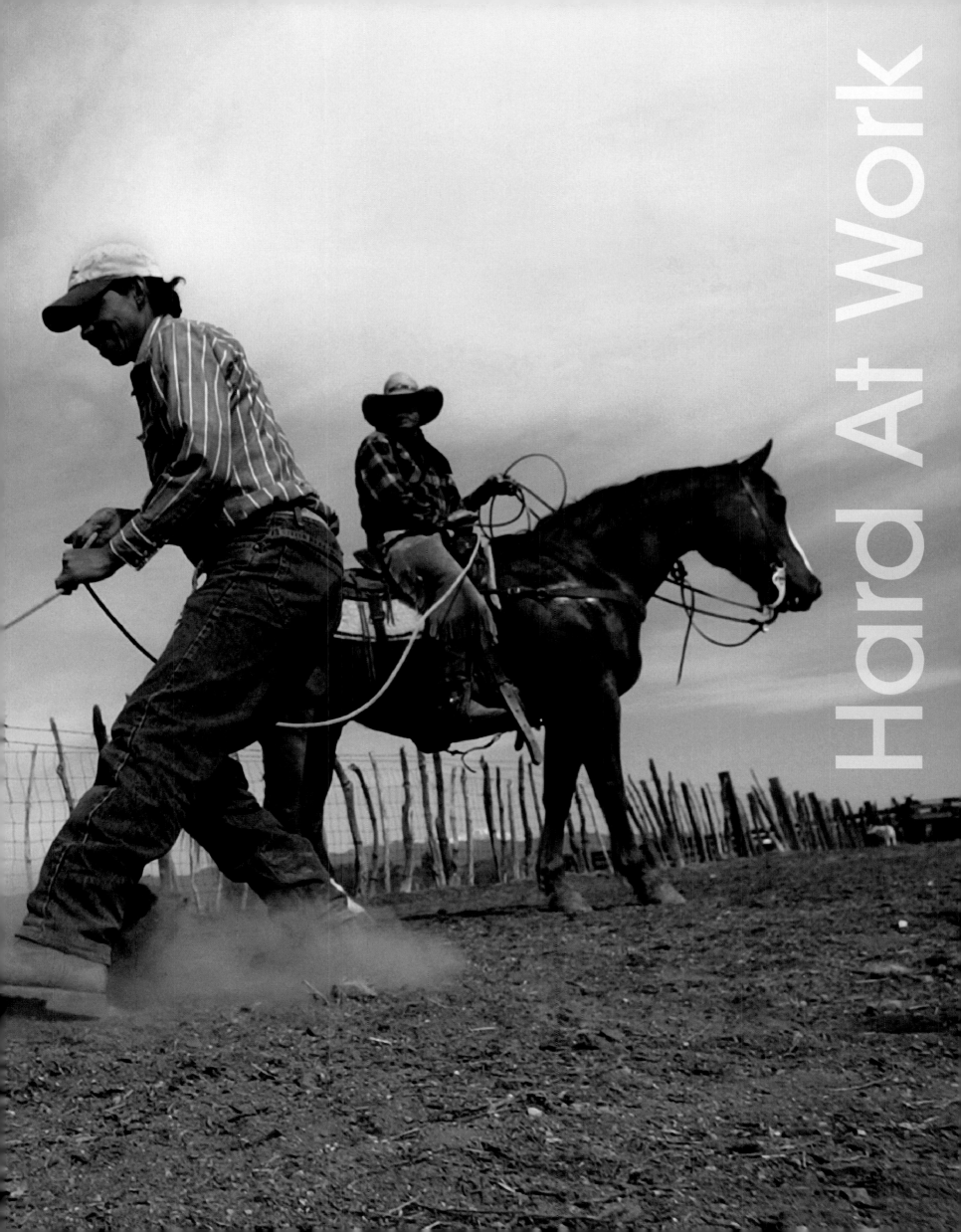

Hard At Work

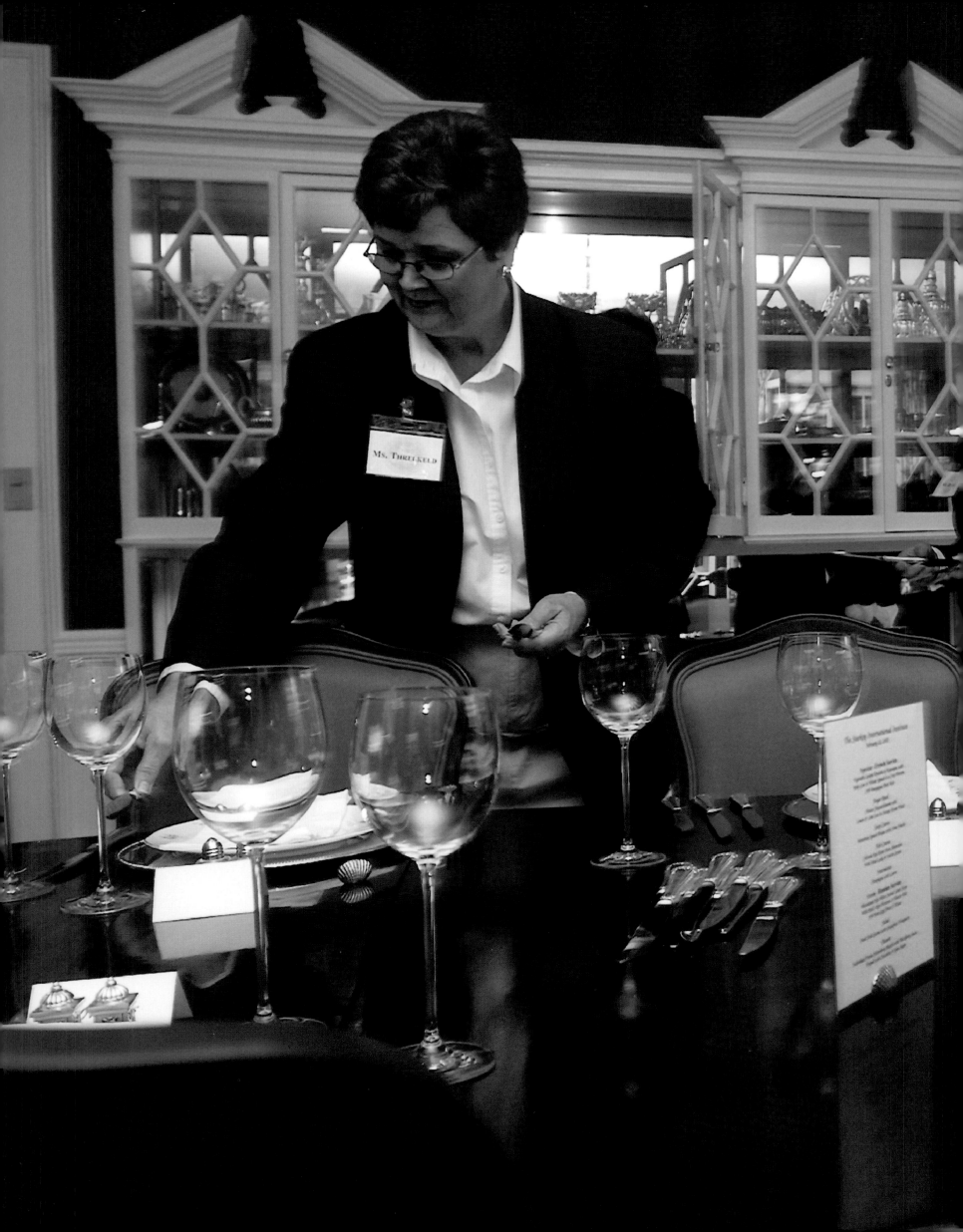

DENVER
Butlers-in-training learn to set a formal dinner table at the Starkey International Institute for Household Management, one of only two such schools in the country. Graduates go on to work for America's most affluent families after they've completed the school's 360-hour curriculum, which covers subjects such as fur care, wine selection, oriental rug cleaning, and so on.
Photo by Kevin Moloney, Aurora

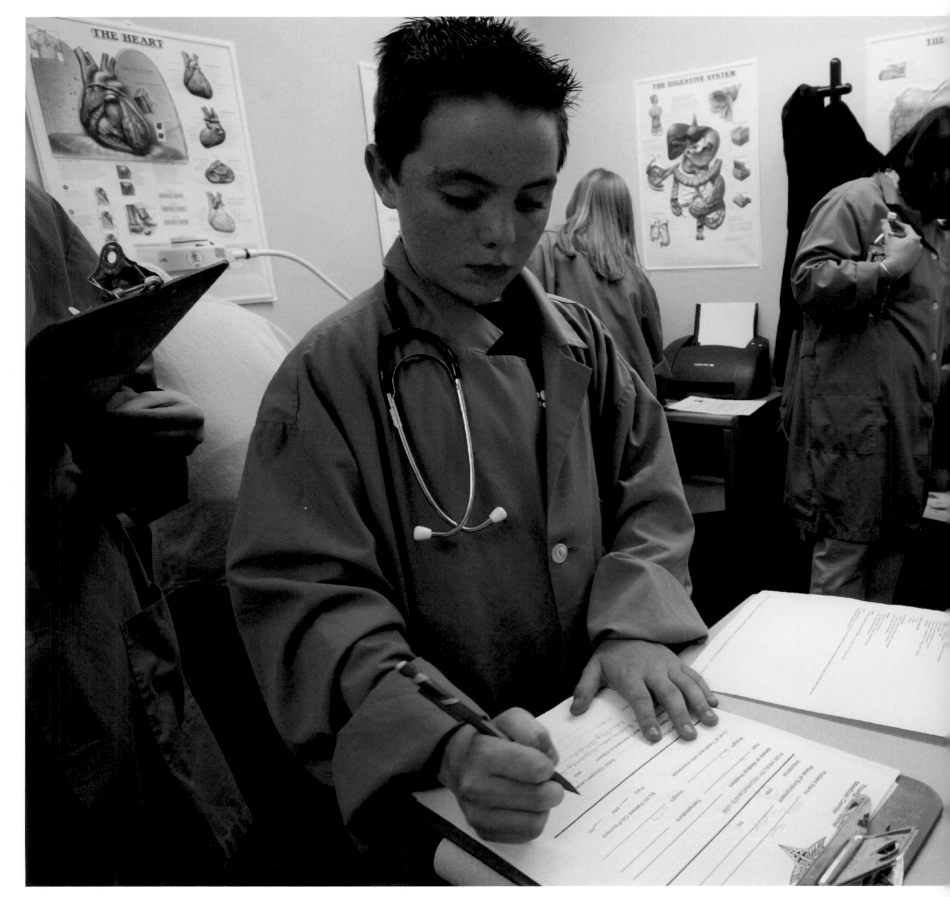

DENVER

No, it's not Doogie Howser. It's fifth-grader Logan Buckner in his medical practice at Young AmeriTowne, a program that teaches youth how to run a town and a business. Each year, 13,500 Colorado students receive a four-hour hands-on lesson and live in the adult world for a day.

Photos by Trevor Brown, Jr.,
Rich Clarkson & Associates

DENVER

Since 1990, Young AmeriTowne has introduced more than 140,000 youngsters to the worlds of banking, personal finance, media, and government. AmeriTowne's TV station anchor Esther Mignerey reviews a news story with producer Adri Padilla.

DENVER

Mayor John Swenson and Judge Jorgie Griffen confer on a pressing issue at Towne Hall.

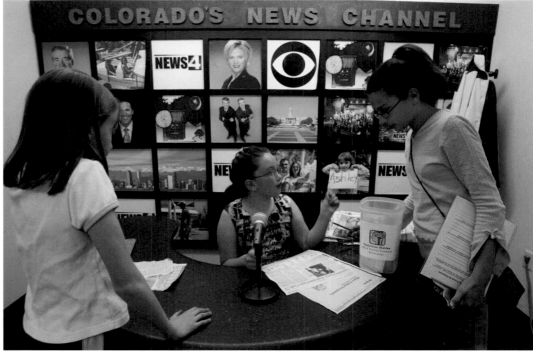

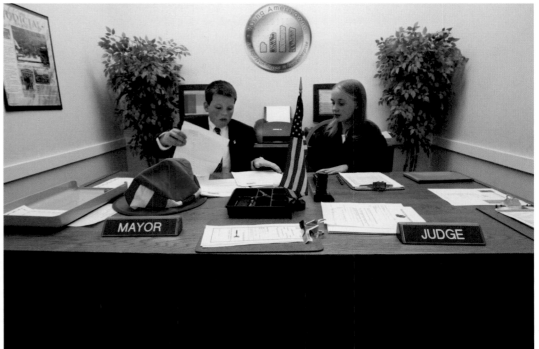

DENVER
Emergency Medical Technician Bob Blechan hoses down the ambulance garage. Denver Health Paramedic Division, the sole responder to 911 calls for the city and county of Denver, fields more than 64,000 calls per year.
Photo by Peter Lockley

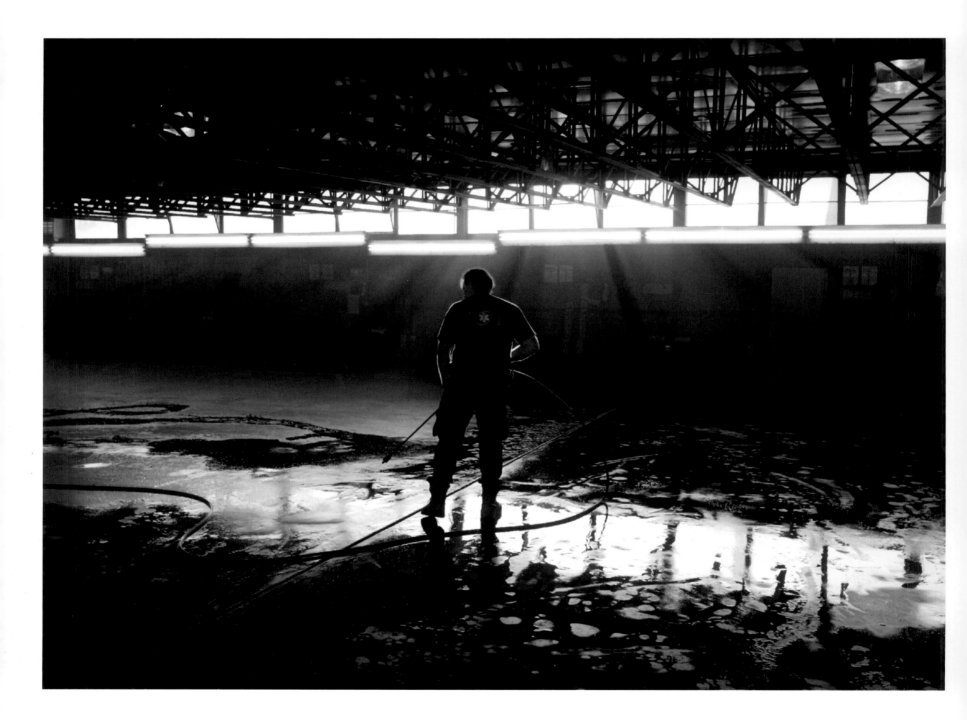

FORT COLLINS

Jason Tomsic does a little midday maintenance on the top of a fermentation tank at the New Belgium Brewing Company, which has become a paragon of energy conservation. Five years ago, the facility became the first wind-powered brewery in America.

Photo by Patrick Kramer,
Longmont Daily Times-Call

COLORADO SPRINGS
Upper classmen can walk across the United States Air Force Academy's central terazzo—but freshman cadets must double time, stepping on only the thin white marble strips. The Academy graduated its first class in 1959 (women entered in 1976) and has since produced 34,000 officers.
Photo by Mark Reis,
The Colorado Springs Gazette

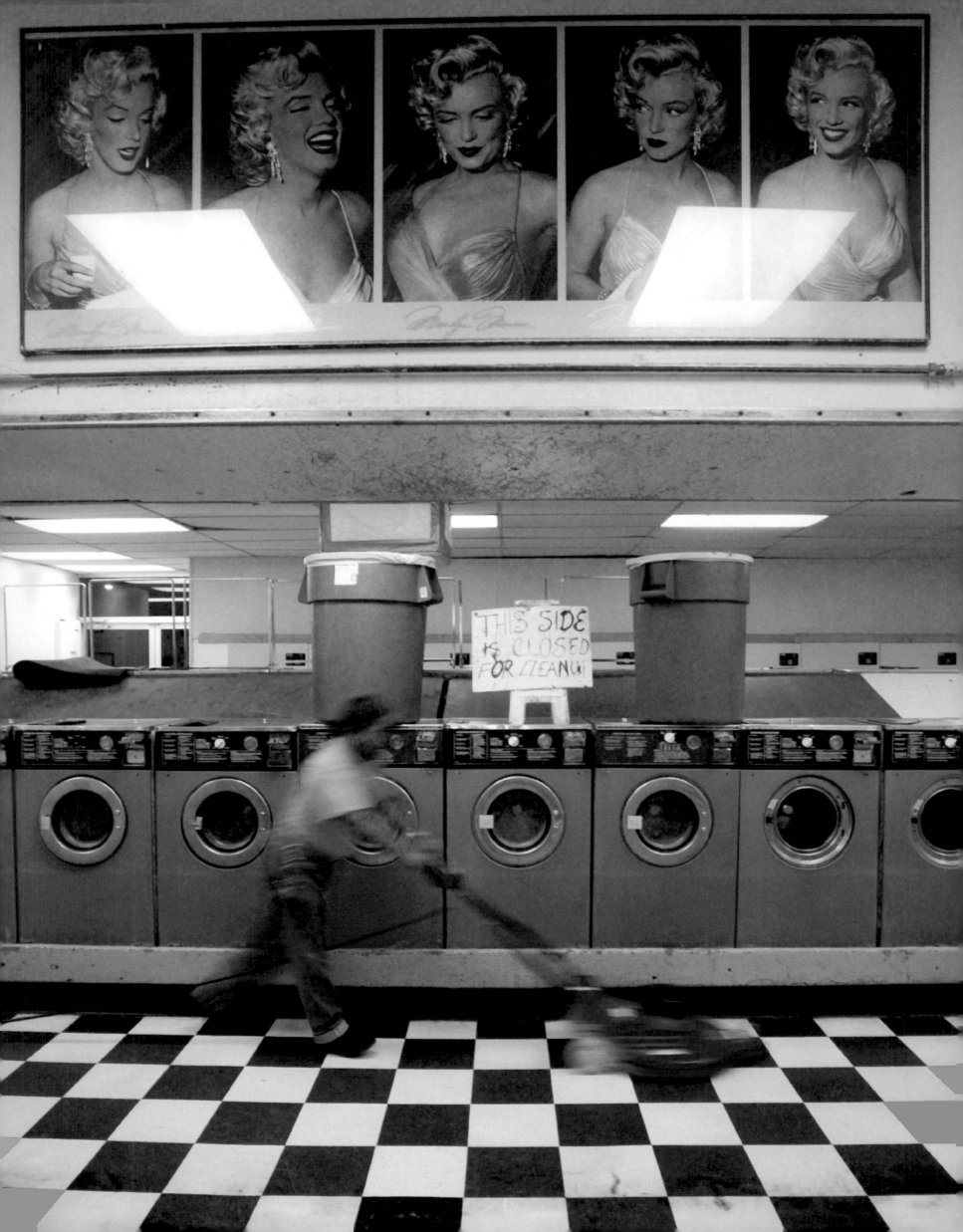

DENVER
Open all night: According to a sign outside, it's "Denver's most exciting landmark." Smiley's Laundromat on Colfax Avenue also claims to be the largest Laundromat in America, with 190 washers and 190 dryers, three coin changers, five detergent dispensers, four video machines, two snack machines, and three pay phones. Night attendant Sammy Mojica polishes the floor.
Photo by Trevor Brown, Jr.,
Rich Clarkson & Associates

EDWARDS
Colorado Gothic: Barbara Jackson and daughters Jamie, 21, and Nikkole, 17, grow vegetables in their mobile home's backyard. Unlike most trailer parks, the government-owned State Trailer Park has only four spaces and plenty of room—plus it sits right on the Colorado River. "We're real lucky," says Barbara. "We only pay $22 a month for all this."
Photo by Emily Yates-Doerr

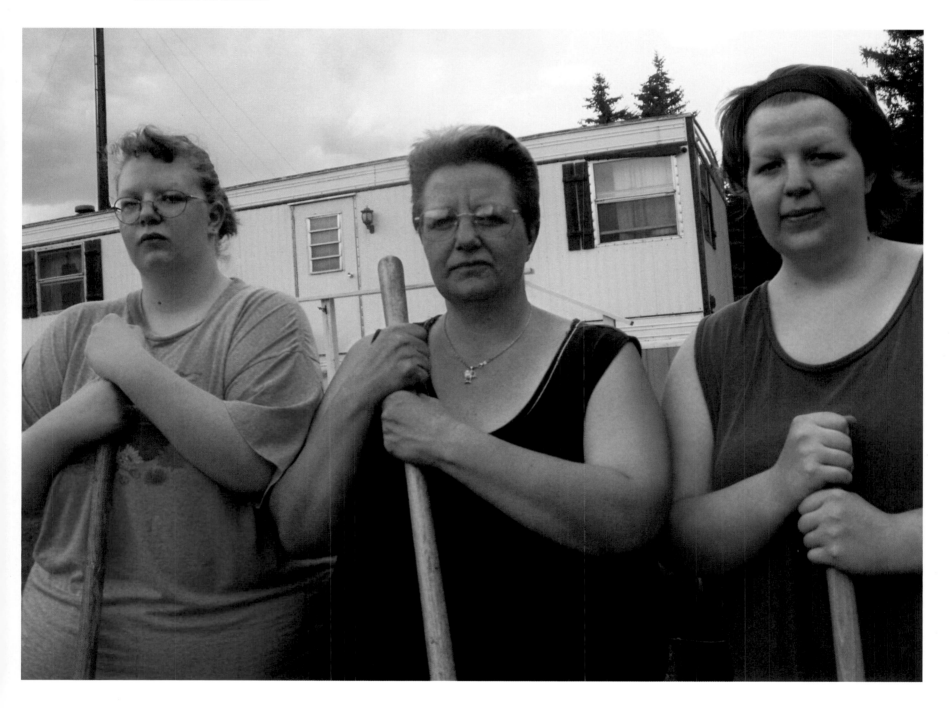

GOLDEN

For 14 years, the Morrison Theatre Company has put on seasonal plays at the Morrison Town Hall. In the brand-new Miners Alley Theatre, the company will operate all year long. Denver artist Daniel Lowenstein works on a mural for the 120-seat theater, which opened in downtown Golden in June 2003.
Photo by Jeff R. Warner

At the end of a hard day, employee Austin White noticed that Katie Kiernan, owner of The Day Spa, was frazzled. White offered to stay late and give her a one-and-a-half-hour facial. "She did it on her own time. It was so sweet," says Kiernan.
Photo by Robert Millman

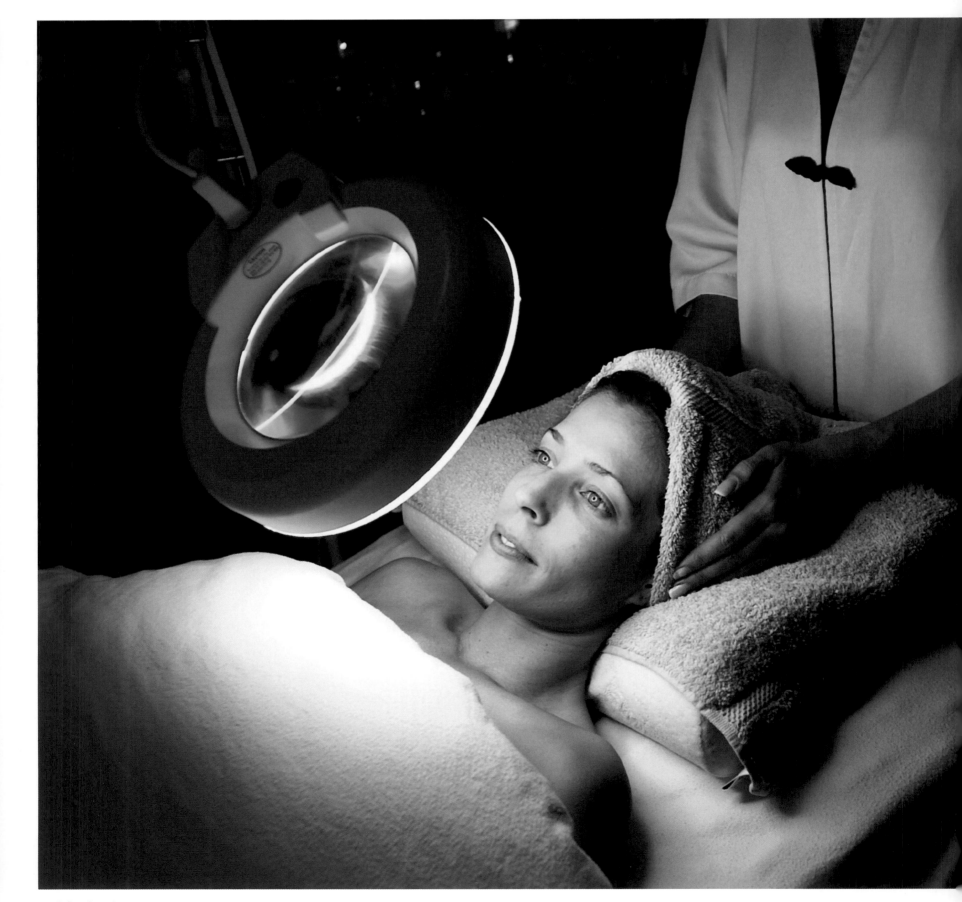

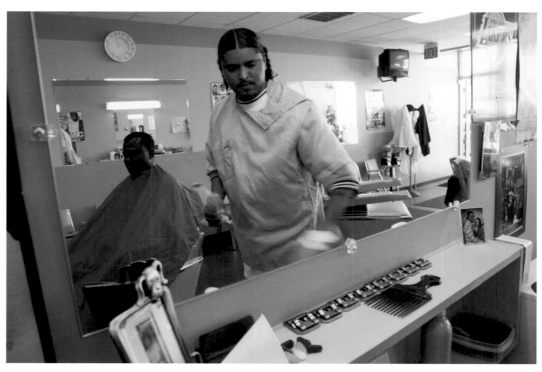

DENVER

With six chairs, the Hollywood Barber Shop on East Colfax has been maintaining Denver heads for 50 years. Jarrod King takes care of Cincinvi D'Almeida, a regular.

Photo by Trevor Brown, Jr.,
Rich Clarkson & Associates

ASPEN

On a faux runway, teenage graduates of Bellavita Academy's modeling course demonstrate their catwalk techniques to parents.

Photo by Robert Millman

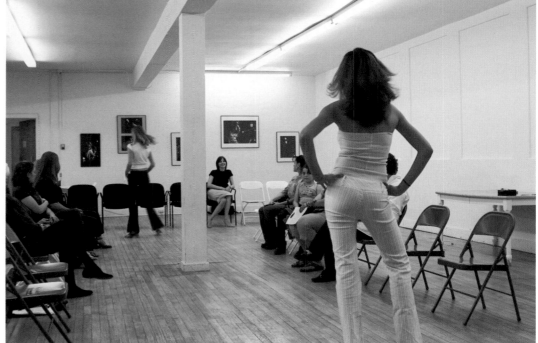

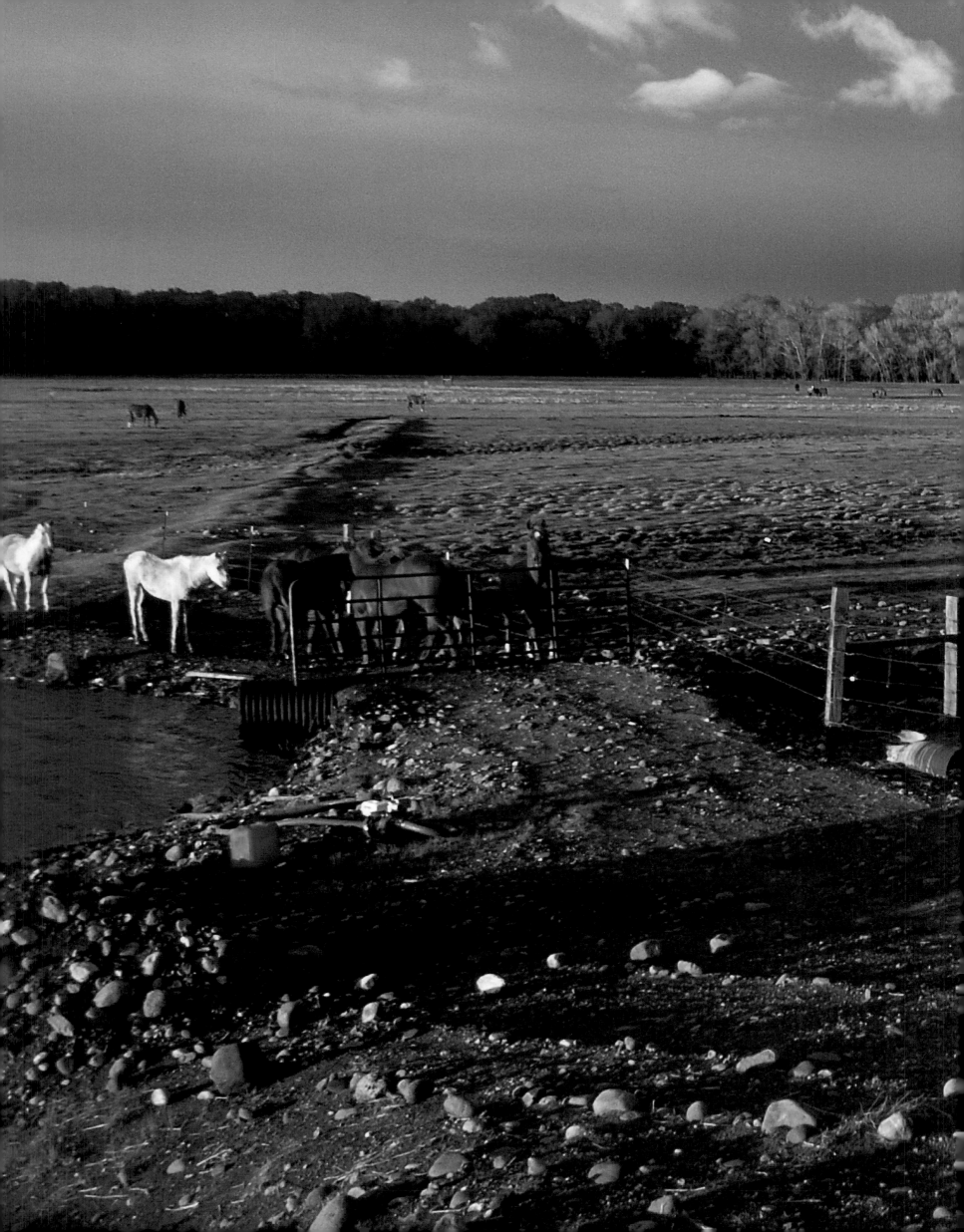

SOUTH FORK
Silo Ranch foreman Jeff Schaffer rescues a mother and her colt from a jealous dry mare, (a horse who never foaled). "They'll steal a baby by kicking and biting a horse until she gives up on her colt," says Schaffer. If the covetous mare succeeds, hers is a Pyrrhic victory—the colt will perish without its birth mother's milk.
Photo by Michael S. Lewis

GUNNISON COUNTY

Sheepherder Aguipin Chavida searches for lost sheep on the high alpine terrain near McClure Pass (elevation 8,755 feet). The migrant worker from Chihuahua, Mexico, manages the flock full time and lives alone in a small trailer outside of the town of Somerset.

Photos by Todd Heisler, Rocky Mountain News

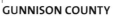

GUNNISON COUNTY

Several labor lawsuits filed between 2000 and 2003 have brought to light the working conditions of migrant sheepherders. Many toil in the country's remotest regions without access to medical care. The work is physically demanding and requires herders to be on call 24 hours a day, seven days a week. They are paid as little as $3 an hour.

GUNNISON COUNTY

Before heading out for a second shift just before nightfall, Aguipin Chavida gets an energy boost with a hot cup of coffee. Migrant sheepherders like Chavida work in the U.S. for up to three years under the federal H-2A visa program. Although he is from Mexico, most herders are from the Andean region of Peru where sheepherding is a common profession.

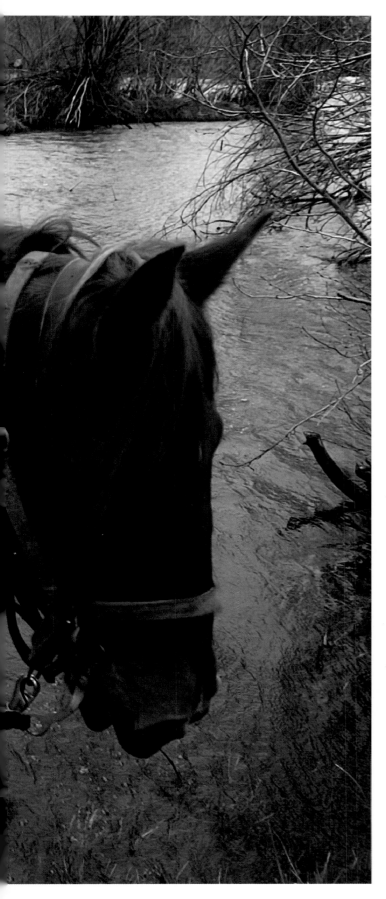

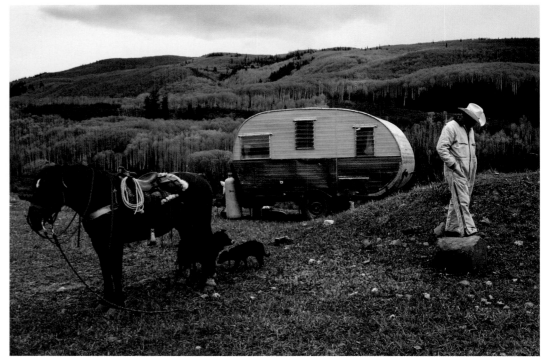

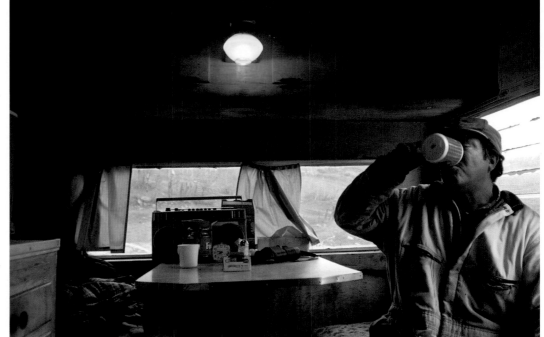

EL PASO COUNTY

During the month-long, spring branding season, families from seven neighboring ranches help Jay Frost on his 24,000-acre spread, which has been in the family since the 1950s. "We've been doing it this way forever," says Frost. "We'd have to hire a branding crew if we didn't give each other a hand."

Photo by Mark Reis,
The Colorado Springs Gazette

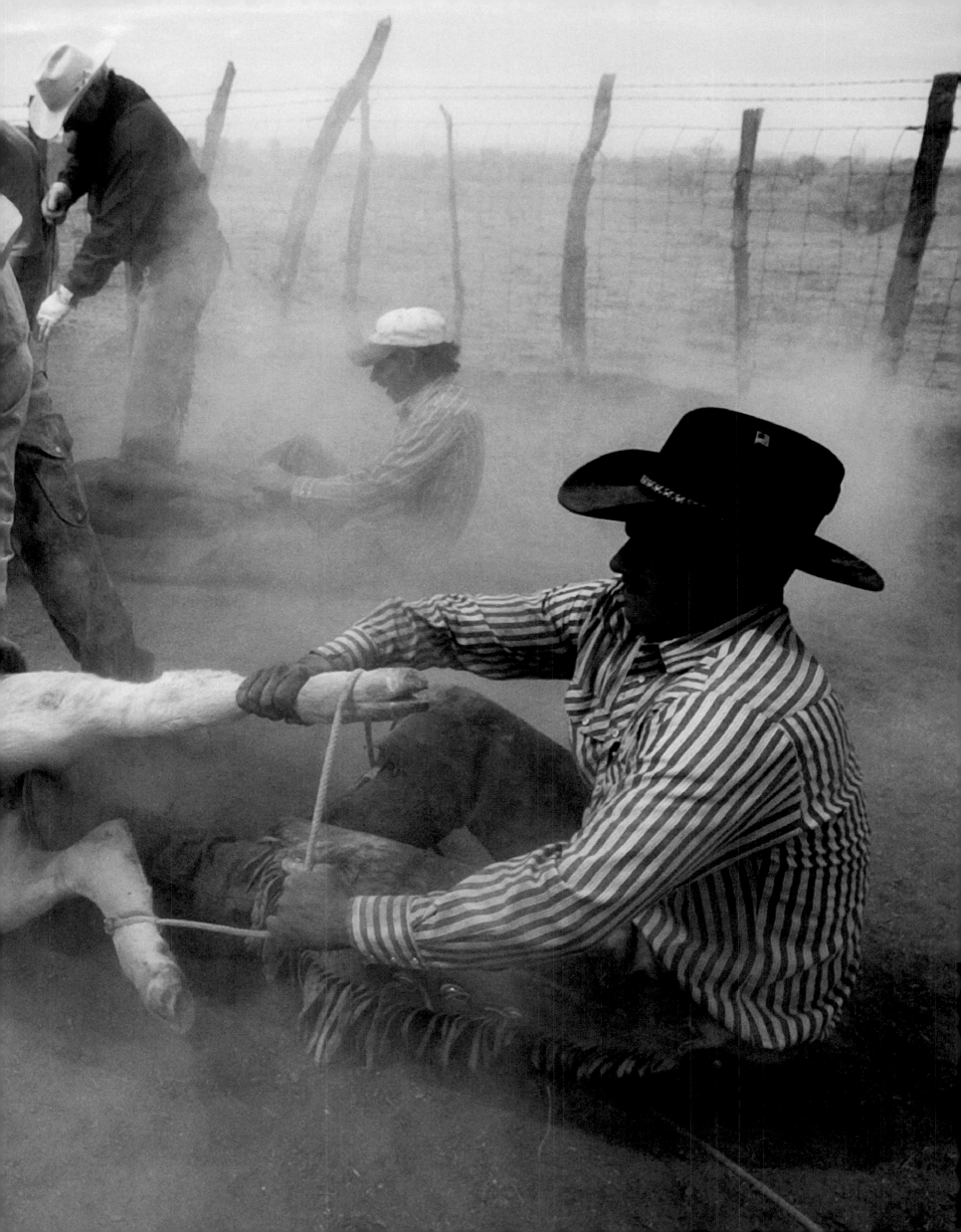

EL PASO COUNTY

Thirteen-year-old Maggie Hanna bites into a Rocky Mountain oyster (grilled calf testicle) while helping out with spring branding at Fountain Creek Ranch. At the age of six, Maggie went to her first roundup where she tasted her first oyster (also called cowboy caviar). "The ones at restaurants are better, but these are more authentic," she says.
Photo by Mark Reis,
The Colorado Springs Gazette

STEAMBOAT SPRINGS
Blake Sander applies Stanko Ranch's brand
to a calf during the annual spring roundup.
Owned by Jim and Jo Stanko, the ranch is in
the Yampa Valley, 157 miles northwest of
Denver.
Photo by Rod Hanna

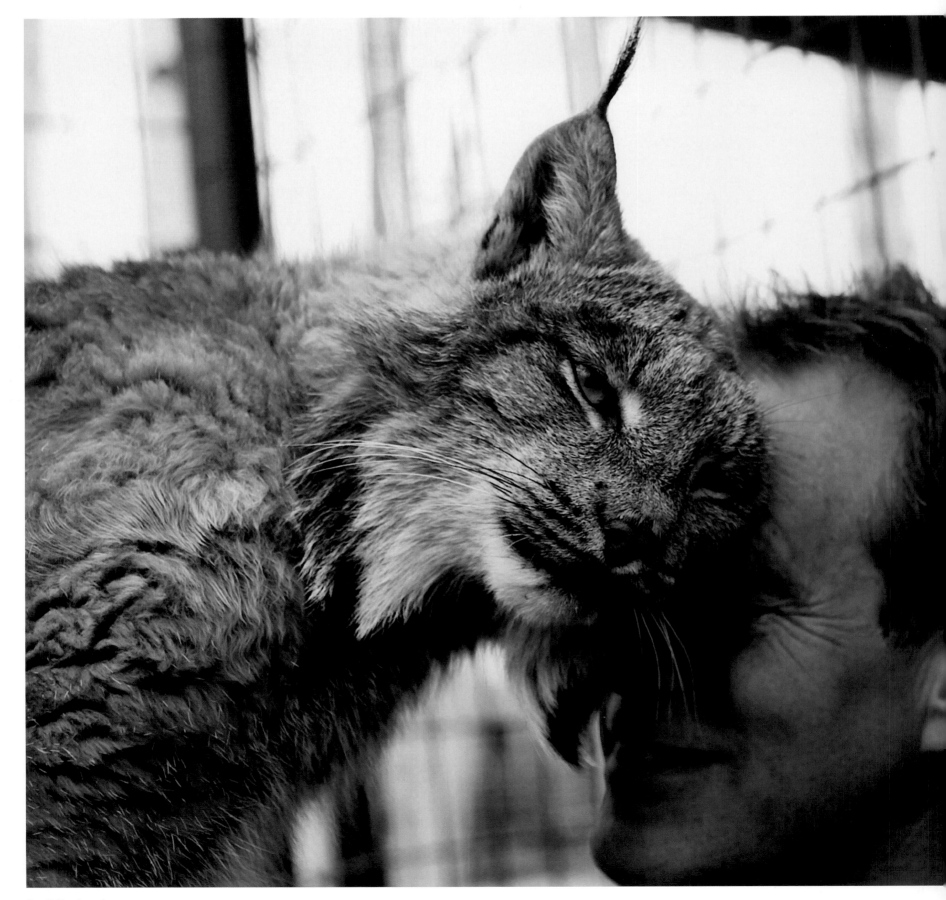

TELLURIDE

Aslan, a confiscated Canadian lynx, welcomes volunteer Tim Mill with a head nuzzle. The cat was mistreated by his previous owner and is now a permanent resident of Rocky Mountain Ark Wildlife Rehabilitation Center. Orphaned, injured, and abused animals (both wild and domestic) are brought to the 14-acre refuge, where most are nursed back to health and set free.

Photo by Robert Millman

CALHAN

One of nine mountain lions at Mountain Vista Ranch Wildlife Park, Kira is generally antisocial but not with owner Keith Clendaniel. The park takes in pets that can no longer be cared for, as well as animals with medical problems, like a 2,000-pound blind bull and a barren yak.

Photo by Henry Hill

CALHAN

Clendaniel gets a smooch from Commanche, a male wolf he raised with his wife at their wildlife sanctuary.

Photo by Henry Hill

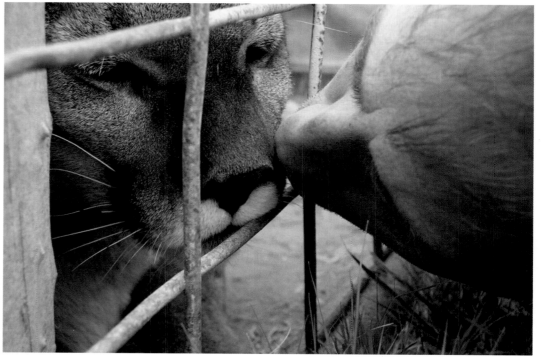

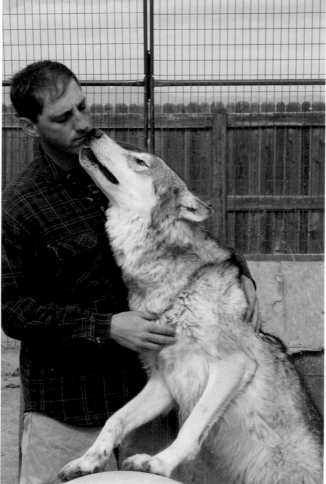

DENVER
Colorado's ongoing four-year drought makes
finding white water a challenge for kayakers
like Todd Toledo. He resorted to surfing the
man-made hydraulics at Confluence Park to
get his fix of river rapids.
Photo by Craig F. Walker, The Denver Post

Colorado At Play

SOUTH FORK
If this rider ropes both the hind legs and horns of his steer in under 7.5 seconds, he has a shot at the team roping jackpot. South Fork ranchers pony up $20 to enter the informal competition held each weekend at Silo Ranch. The winners take home $300.
Photo by Michael S. Lewis

DENVER
Chuck Yeager broke the sound barrier; at 75 mph on Interstate 25, Jaeger the dog breaks the slobber barrier.
Photo by Michael S. Lewis

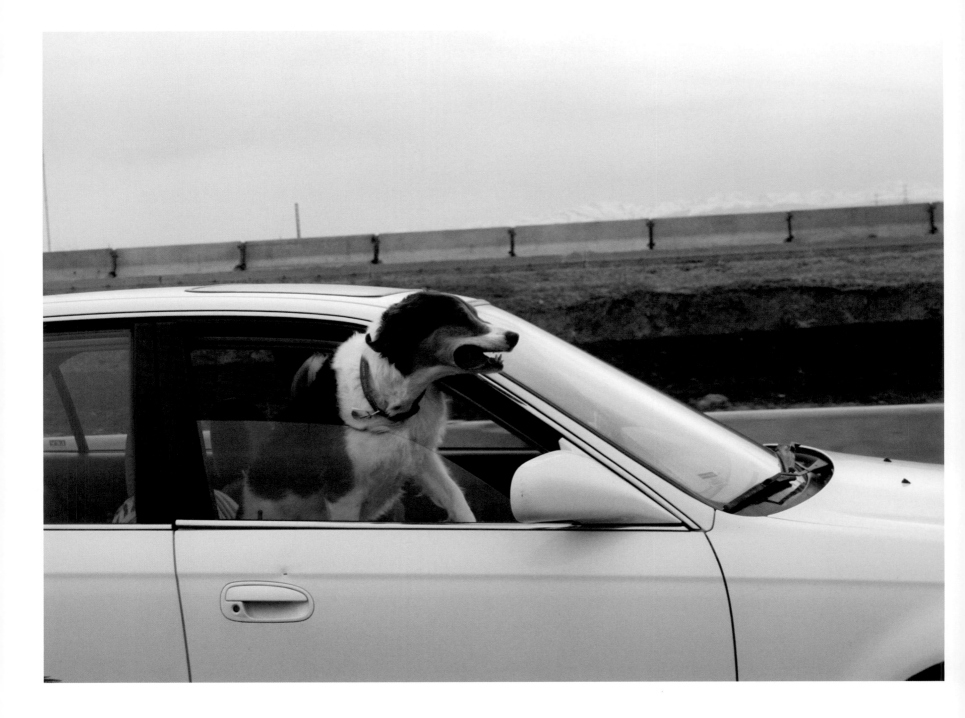

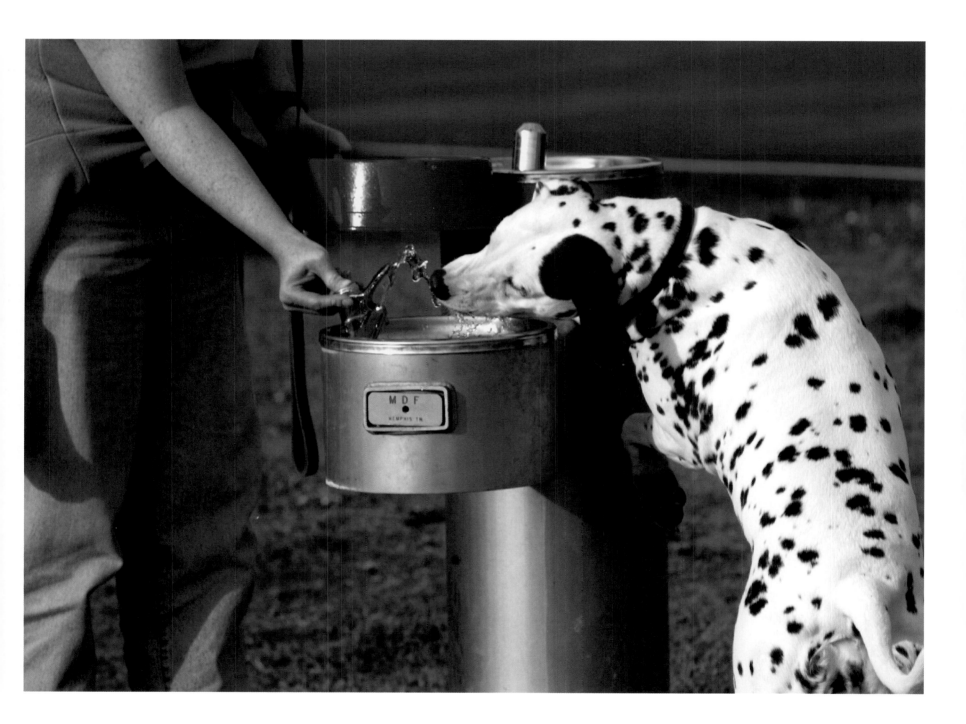

ENGLEWOOD

That hits the spots: Shasta refuels after romping
with pals at a get-together of the 7 O'Clock Club.
Dogs and their owners meet up every weekday at
7 a.m. and 7 p.m. in Bates & Logan Park, one of
the few in Englewood with an off-leash policy.
Photo by Jamie Schwaberow,
Rich Clarkson & Associates

SUMMIT COUNTY
Après-ski bums: Dan Phillips presides over his
annual beach party at the base of Arapahoe Basin.
Photos by Jacob Pritchard

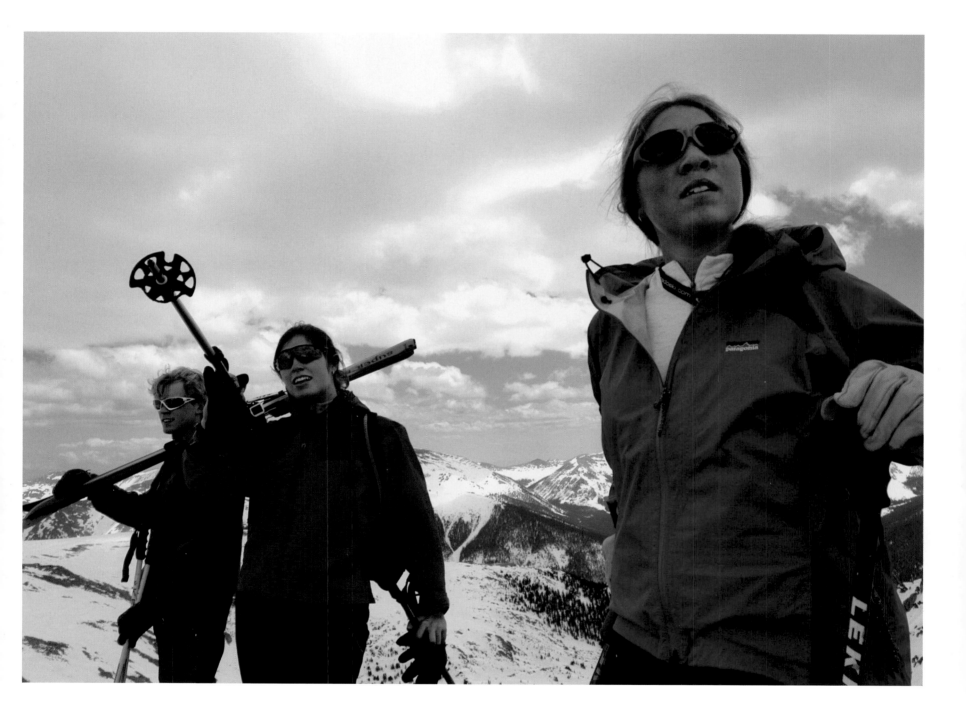

SUMMIT COUNTY

After trudging up the face of Arapahoe Basin's Upper East Wall, a trio of powder hounds contemplates which of four double-black-diamond runs to descend. At 13,050 feet. the mountain's east peak drops off into a series of steep chutes, providing 1.5 miles of heart-stopping vertical.

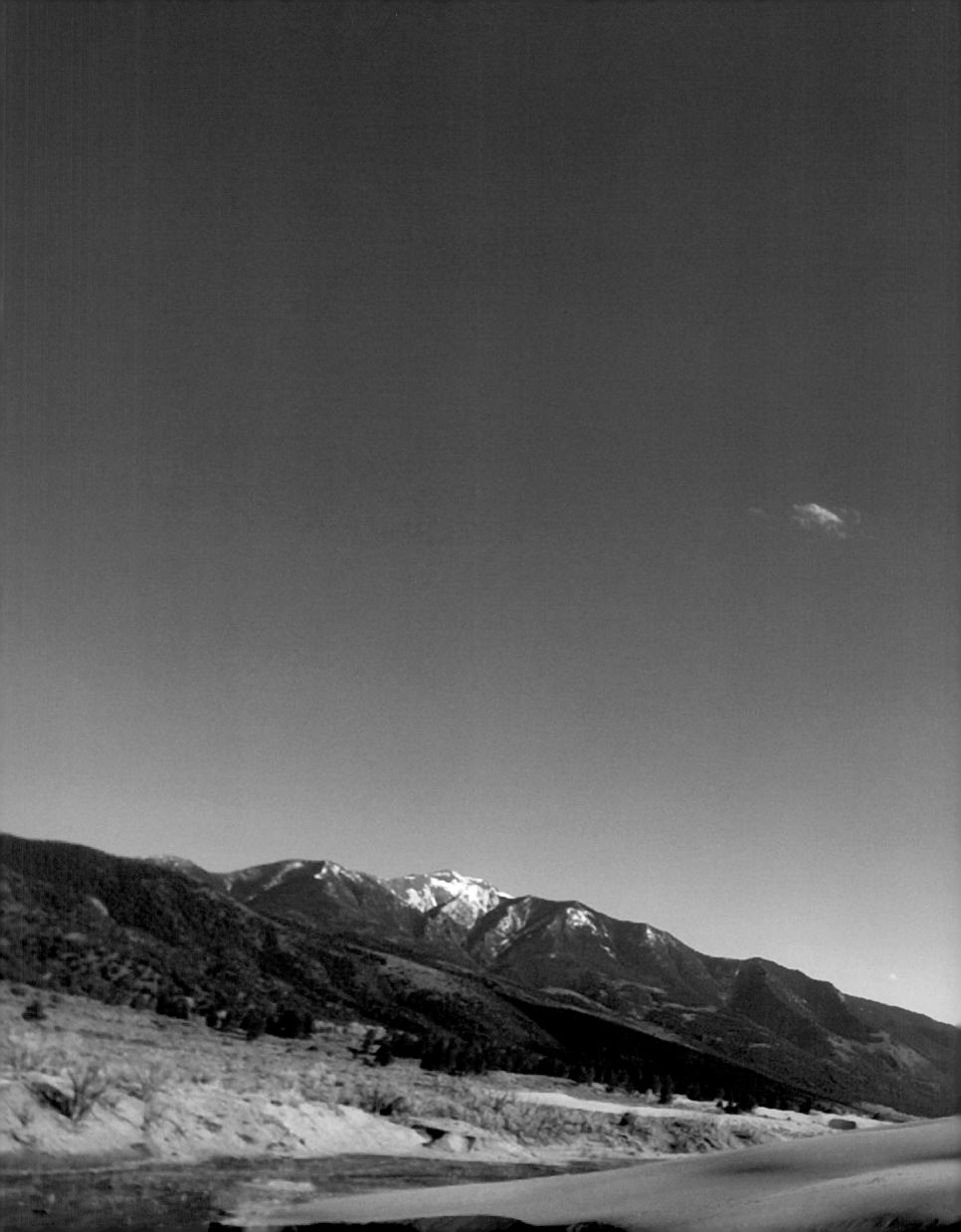

MOSCA
Seth Walker celebrates his graduation from Adams State College with a little off-season snowboarding at Great Sand Dunes National Monument. This geologic wonderland contains 30 square miles of the tallest dunes in America, some as high as 750 feet. An avid boarder, Walker has been known to ride the sand at night, illuminated by headlights.
Photo by Mark Reis,
The Colorado Springs Gazette

BUENA VISTA

With Mount Yale and a gentle breeze at their backs, two roadies conserve energy in the slipstream behind their lead rider. Five hundred cyclists converge on Buena Vista each spring for the annual Bike Fest ride, a 60-mile circuit through the Collegiate Peaks Wilderness Area.

Photo by Michael S. Lewis

STEAMBOAT SPRINGS
Melissa Campagna of Hayden is the winner of the third annual Soap Box Derby event in Steamboat Springs. Her next stop? The 65th annual All-American Soap Box Derby in Akron, Ohio, where she'll compete with more than 400 nationwide winners.
Photo by Rod Hanna

SOMERSET

The Portal in downtown Somerset (pop. 185) has been a coal miners' hangout for nearly 50 years. Retired miners like Martin Brezonick, 85, come 'round just about every day for beer and conversation. Occasionally, unexpected visitors pop in: Goldie Hawn and Kurt Russell downed a few cold ones at the bar a few years back.

Photo by Todd Heisler, Rocky Mountain News

DENVER

Every Wednesday night at the PS Lounge there's a guest bartender. Tonight it's Amy Marolf, a four-year patron of the Colfax Avenue watering hole. "Bartending is a lot harder than it looks," says Marolf, who gets a high-five from Greg Carney, her day-job boss in the Denver Broncos marketing department.

Photo by Jamie Schwaberow,
Rich Clarkson & Associates

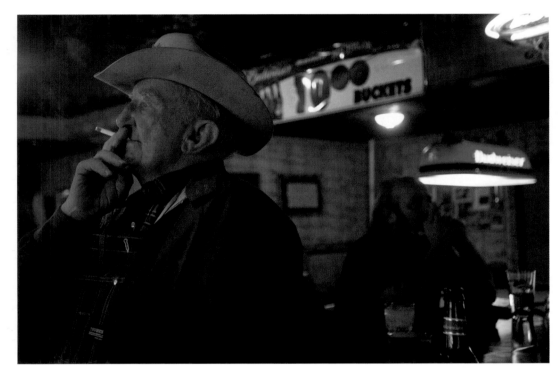

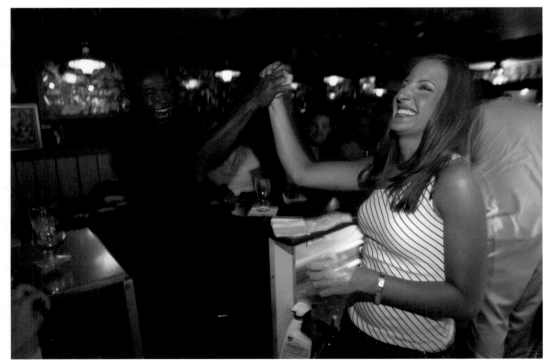

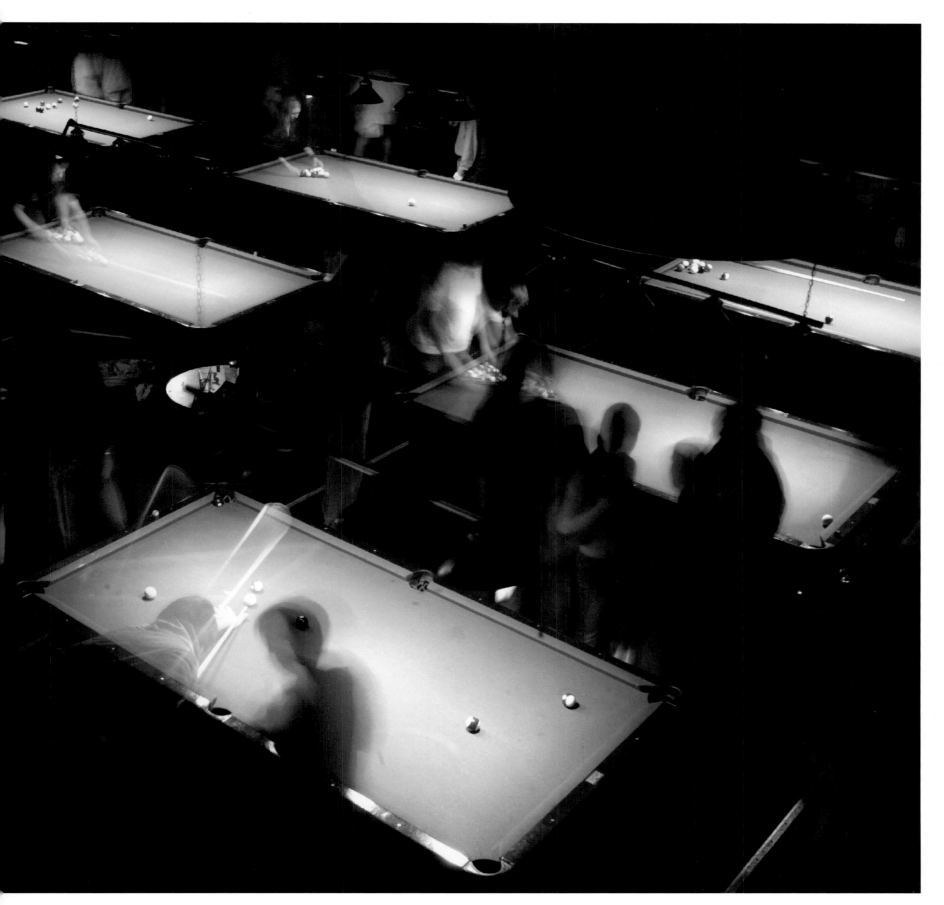

BOULDER
University of Colorado students shoot pool at the
Foundry in the Pearl Street bar district.
Photo by Peter Lockley

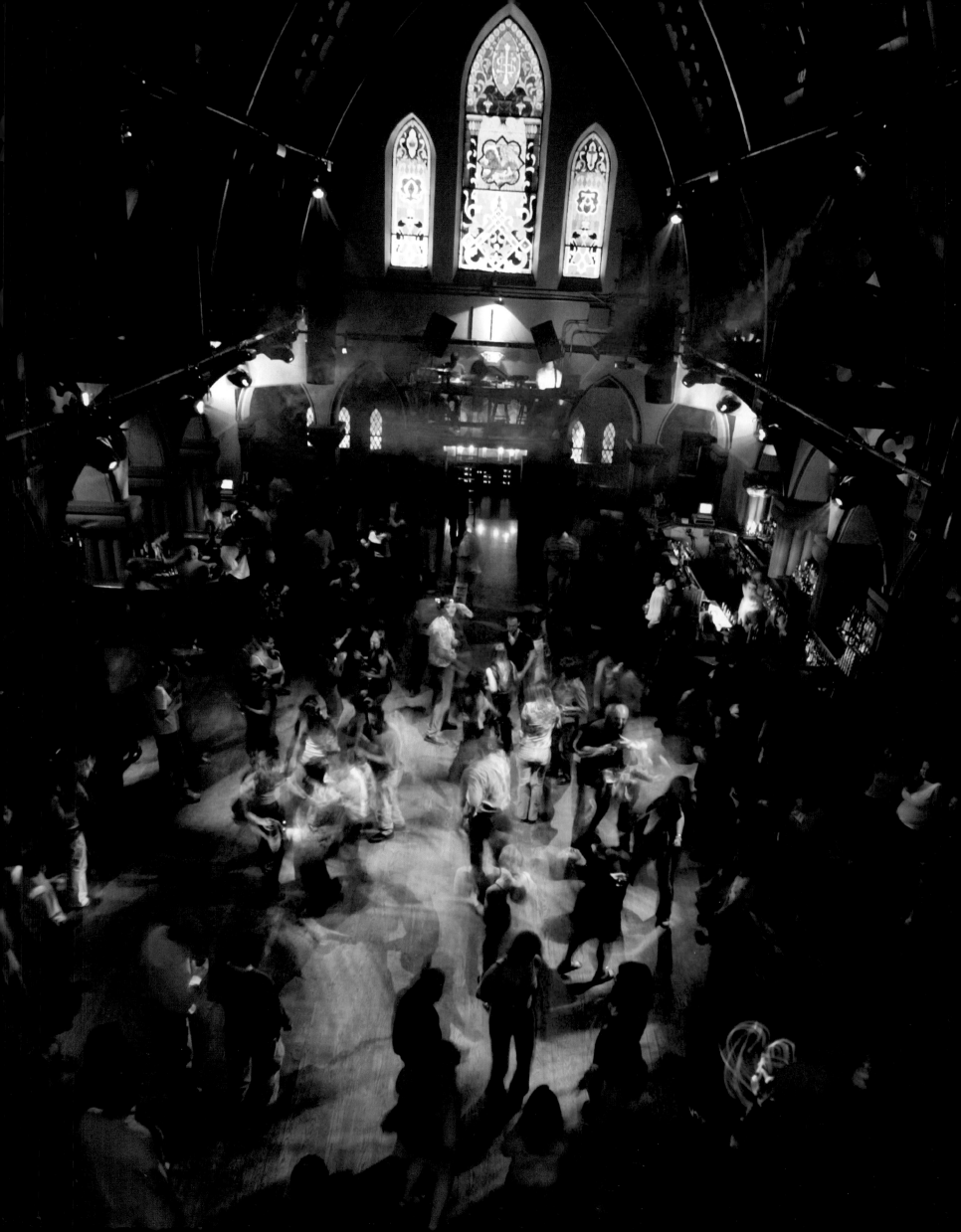

DENVER

A cigar bar, psychedelic lighting, rooftop deck, sushi bar, and famous DJs make this former church, now known as The Church, a big draw for Denver's singles

*Photos by Jamie Schwaberow,
Rich Clarkson & Associates*

DENVER

Fredi & The Soul Shakers bring down the house at The Church. The group has been serving up soul, funk, blues, and Motown for the past seven years.

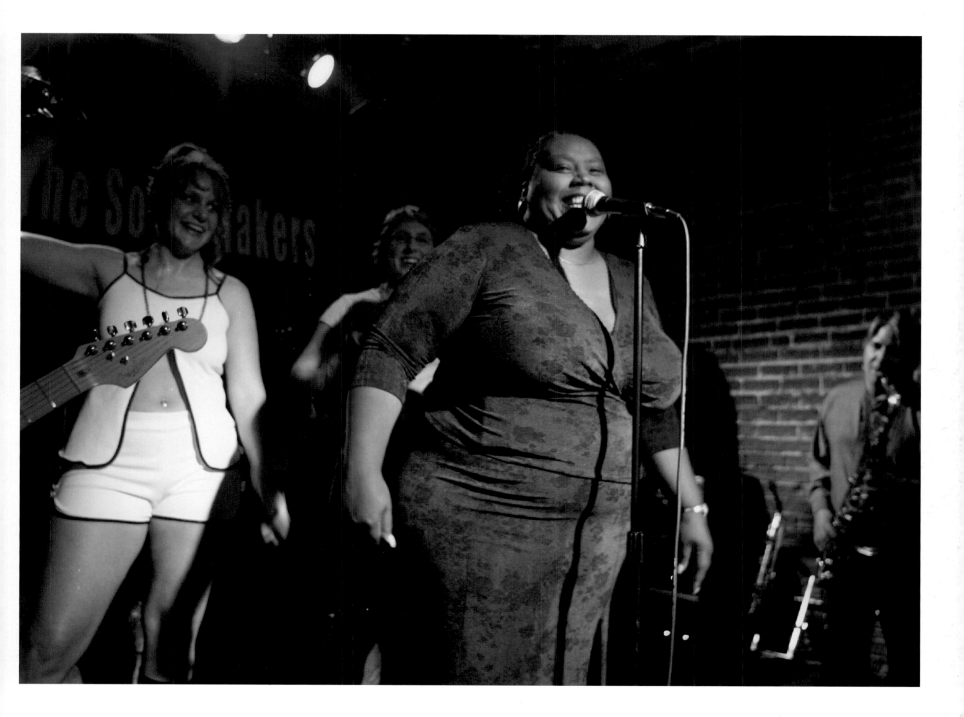

ENGLEWOOD

Collin DeSimone waits for the Sinclair Middle School band director to finish his lesson so he can do what he loves. "It gives me a rush when I play," the 13-year-old says. "It's just cool."
Photo by Craig F. Walker, The Denver Post

BRECKENRIDGE

Attorney Jon Crowder leads a bimonthly drum circle at Mountain Java Coffee & Books. Drumming is thought to improve well-being, and for these gatherings, no training is required. "Within 10 minutes, the group is playing rhythms and making music through their collective spirits," says Crowder.
Photo by Carl Scofield

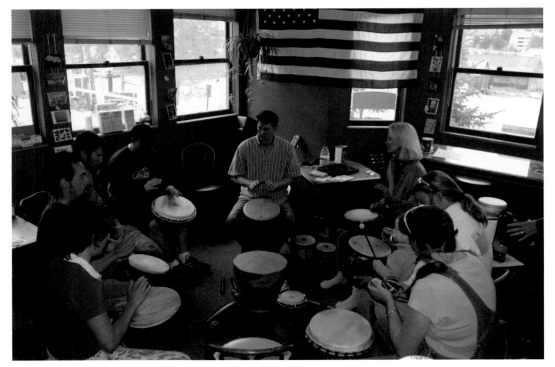

ENGLEWOOD

" get my emotions out through my music," says Nathan Pompi who likes to unwind with his Fender guitar after a day of high school algebra, history, and biology. The 17-year-old plays heavy metal songs like Metallica's "Seek and Destroy" and Iron Maiden's "Hallowed Be Thy Name." "It helps me relax," he says.
Photo by Craig F. Walker, The Denver Post

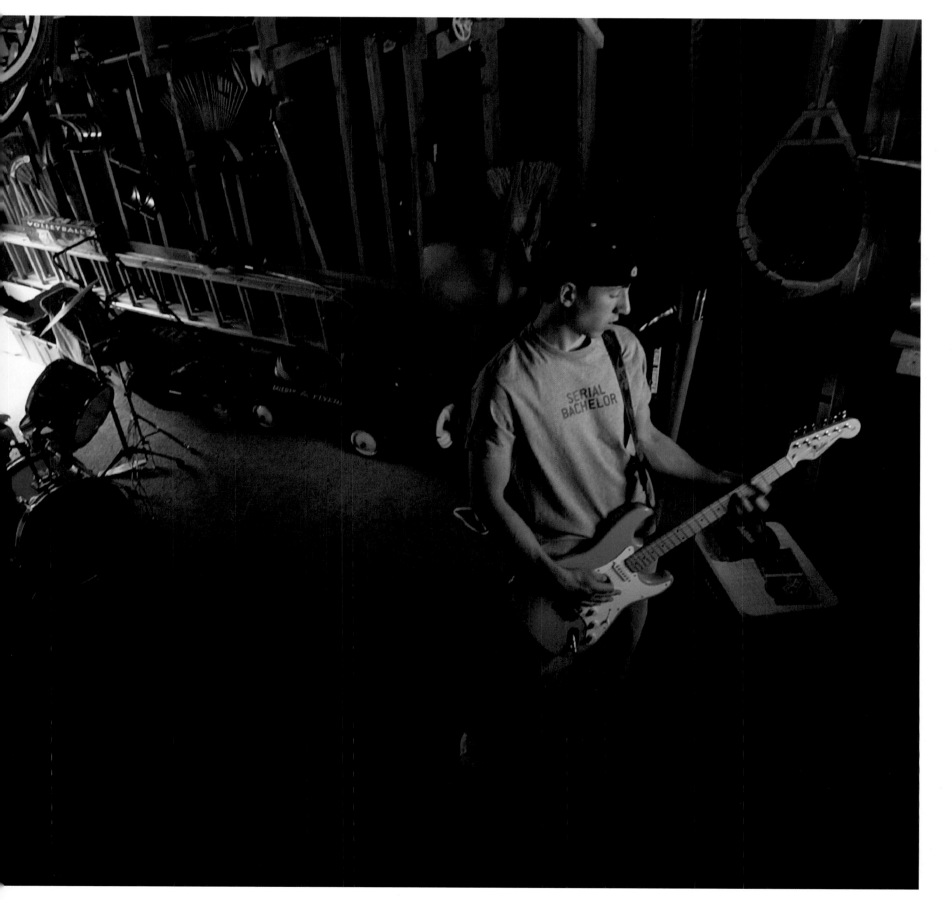

DENVER
Mile High high: Members of the Pomona Panthers high school baseball team celebrate the victory in the 5A (highest class) state championship game. The Panthers beat the Regis Raiders at All-City Stadium in Denver.
Photos by Barry Gutierrez,
Rocky Mountain News

DENVER
Panthers' starting pitcher Jonathan Klausing gets a victory kiss from girlfriend Deanna Blaser.

IDAHO SPRINGS
An important event at the second annual
Westmuttster Dog Show includes donning
a dog helmet and whacking a goat piñata.
Sponsored by the local radio station 102.7
The Goat, the festivity raises money for
the Clear Creek County Animal Shelter.
Photo by Trevor Brown, Jr.,
Rich Clarkson & Associates

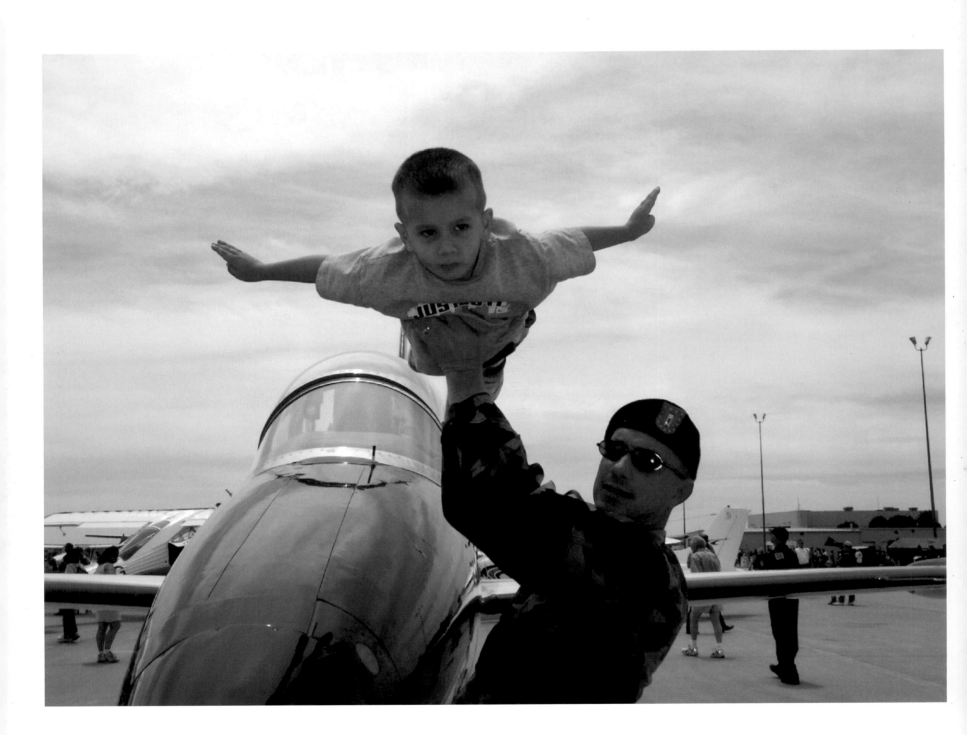

COLORADO SPRINGS
First Lieutenant Bill Shanahan of the Colorado
Army National Guard prepares son Will for take-
off at an air show in the Springs.
Photo by Henry Hill

DENVER
Hugo Holguin challenges gravity on the lip of the
Dog Bowl at the 60,000-square-foot Denver
Skate Park. The concrete playground is the largest
free skateboarding park in the country.
Photo by Craig F. Walker, The Denver Post

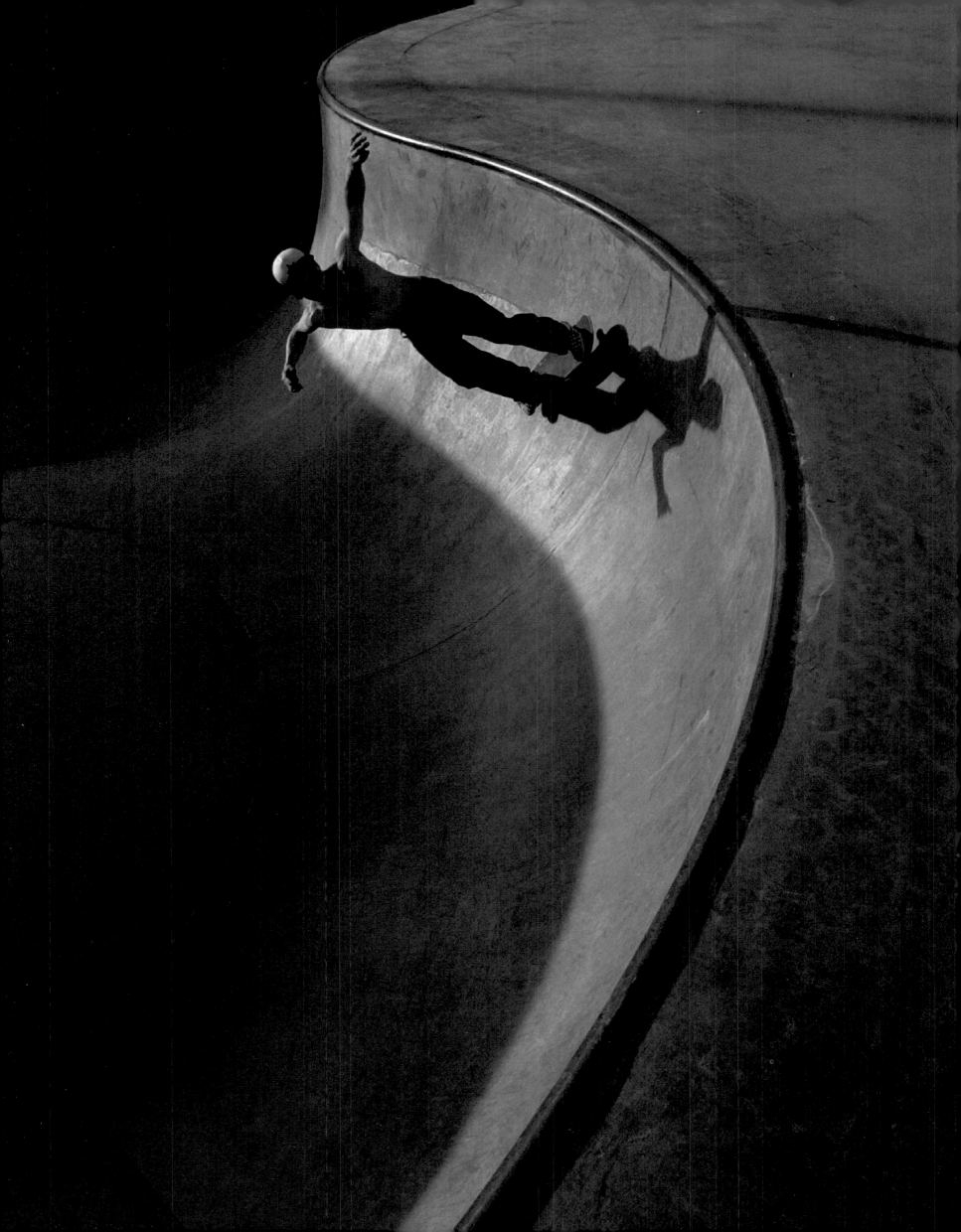

MORRISON

Blake Rudenske conserves energy—and a couple of general admission seats for friends—at Red Rocks Amphitheatre. After waiting in line for most of the day, Rudenske arrived at his seats three hours before the start of the Big Head Todd and the Monsters concert.

Photo by Peter Lockley

MOSCA

Adrielle Giese, Hannah Hoyle, and Chandra Tipton goof around in Medano Creek during a home-schooling outing to Great Sand Dunes National Monument. The girls' families—part of the New Mexico Jehovah's Witness community—home-school separately and join together for educational trips.

Photo by Mark Reis, The Colorado Springs Gazette

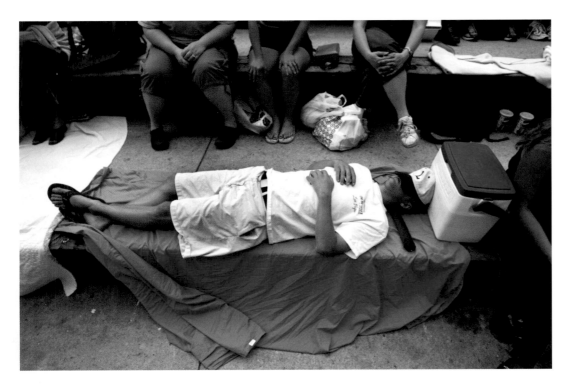

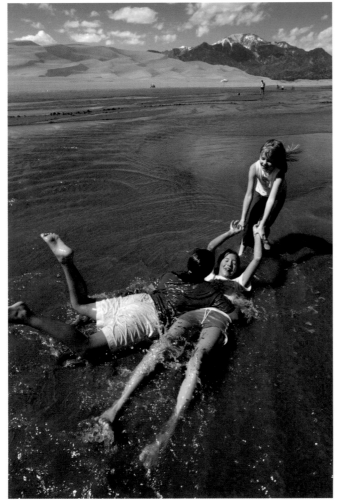

GLENWOOD SPRINGS

Each day 3.5 million gallons of Colorado River water disappear underground near Lookout Mountain and pass over fissures heated by geothermal vents before reemerging at Glenwood Springs Resort. The 104-degree spring provides deep relaxation for visitors like Dave Minter, who soaks by starlight in the resort's therapy pool.
Photo by Todd Heisler, Rocky Mountain News

DENVER
The Colorado Muslim Society's glass dome
spotlights Mohamad Jodeh performing the
Zuhr, or midday prayer.
Photo by Craig F. Walker, The Denver Post

Reason To Believe

SAN LUIS
Graduation is a bittersweet event for the 20 students in Centennial High School's class of 2003. It means saying goodbye to friends they've known since kindergarten. Class President and Valedictorian Jennifer Rodriguez (second from right) will attend the University of Colorado at Colorado Springs in the fall.
Photo by Kevin Moloney, Aurora

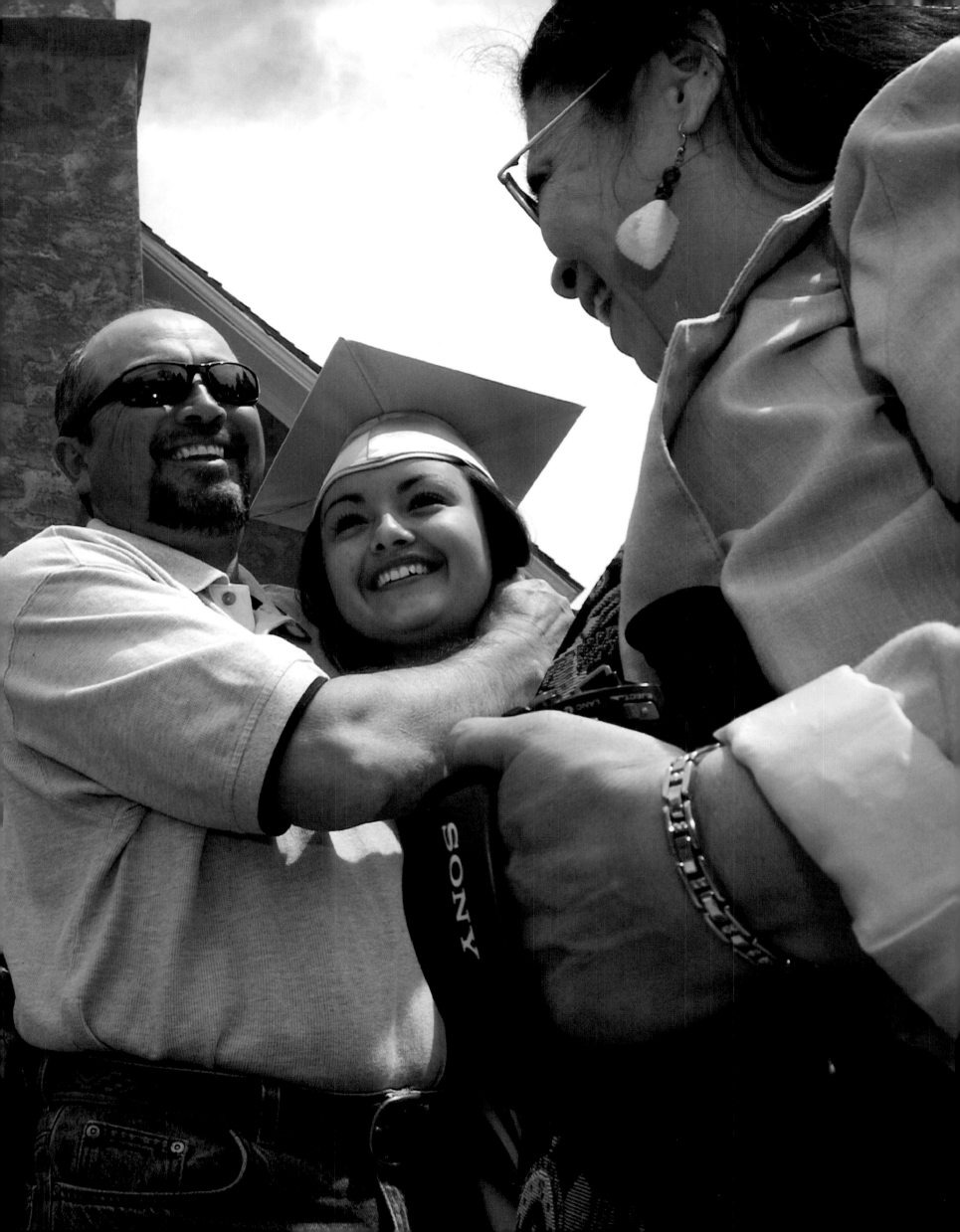

SAN LUIS
Statues depicting the 14 stations of the cross
surround the Capilla de Todos los Santos. Built
in 1997, the chapel was designed to reflect the
history of San Luis—the 800-person ranching
outpost was first settled in the 1840s by Spanish
Mexicans and is the oldest town in Colorado.
Photos by Kevin Moloney, Aurora

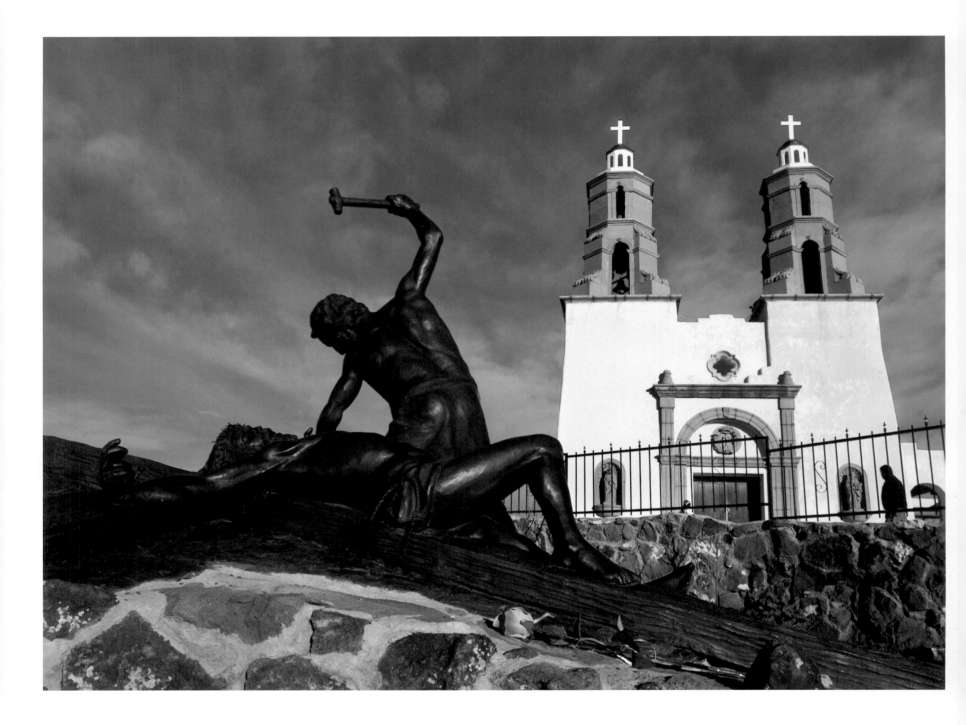

SAN LUIS

Members of Mariachi San Luis liven up Sunday mass at Sangre de Cristo Church. The troupe plays classics like "Guadalajara" and "Las Mañanitas" and wears traditional black, silver-studded *charro* suits for performances. Mariachi bands are usually all male, but San Luis is unorthodox in that half of its members are female.

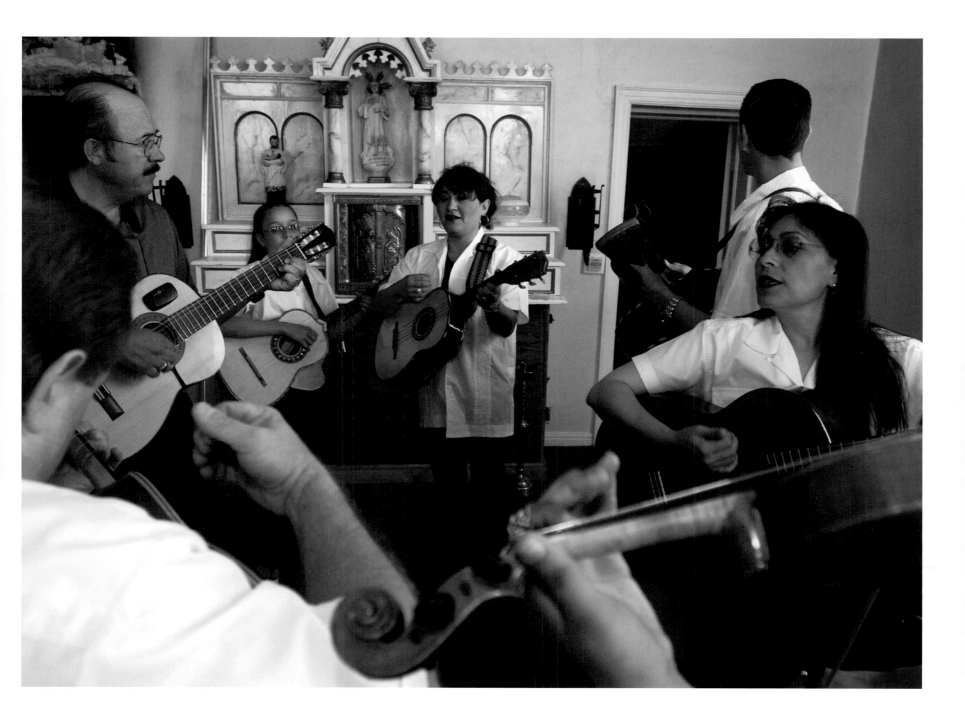

CHERRY HILLS VILLAGE
Father Lawrence Hart kisses his cross before leading Sunday service at the St. George Episcopal Church. Lawrence became an Episcopalian two years ago after ten years as a Mennonite minister. He says his new denomination's liturgical tradition attracted him as did its "contemplative spirituality."
Photo by Craig F. Walker, The Denver Post

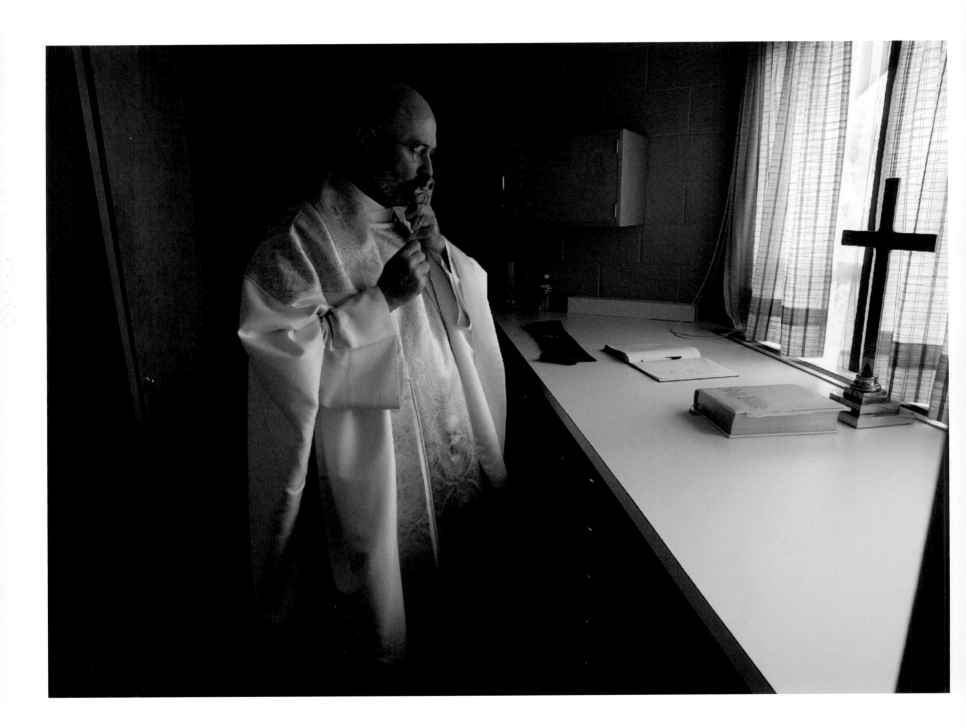

BOULDER

"There was pressure to convert to Mormonism," says Jennifer Latalien, who was raised Catholic in Utah but was nonpracticing. After moving to Colorado in 1998, Latalien attended temple with a friend, talked with a rabbi, and something clicked. She's now converting to Judaism. Every Friday night, she lights two candles and brings in the light of Shabbat.
Photo by David Mejias

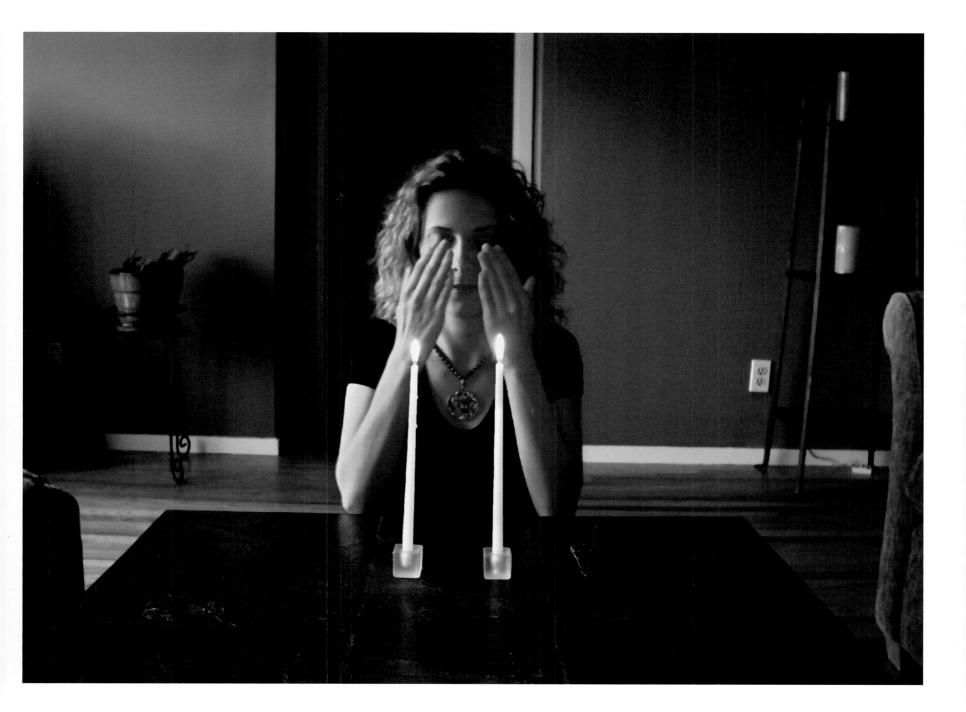

FAIRPLAY

In 1872, Presbyterian missionary Sheldon Jackson started the South Park Community Church. Construction of the Gothic building was completed on October 4, 1874, when the congregation had eight members. Jackson built a total of 100 churches in the West between 1869 and 1882.

Photo by Carl Scofield

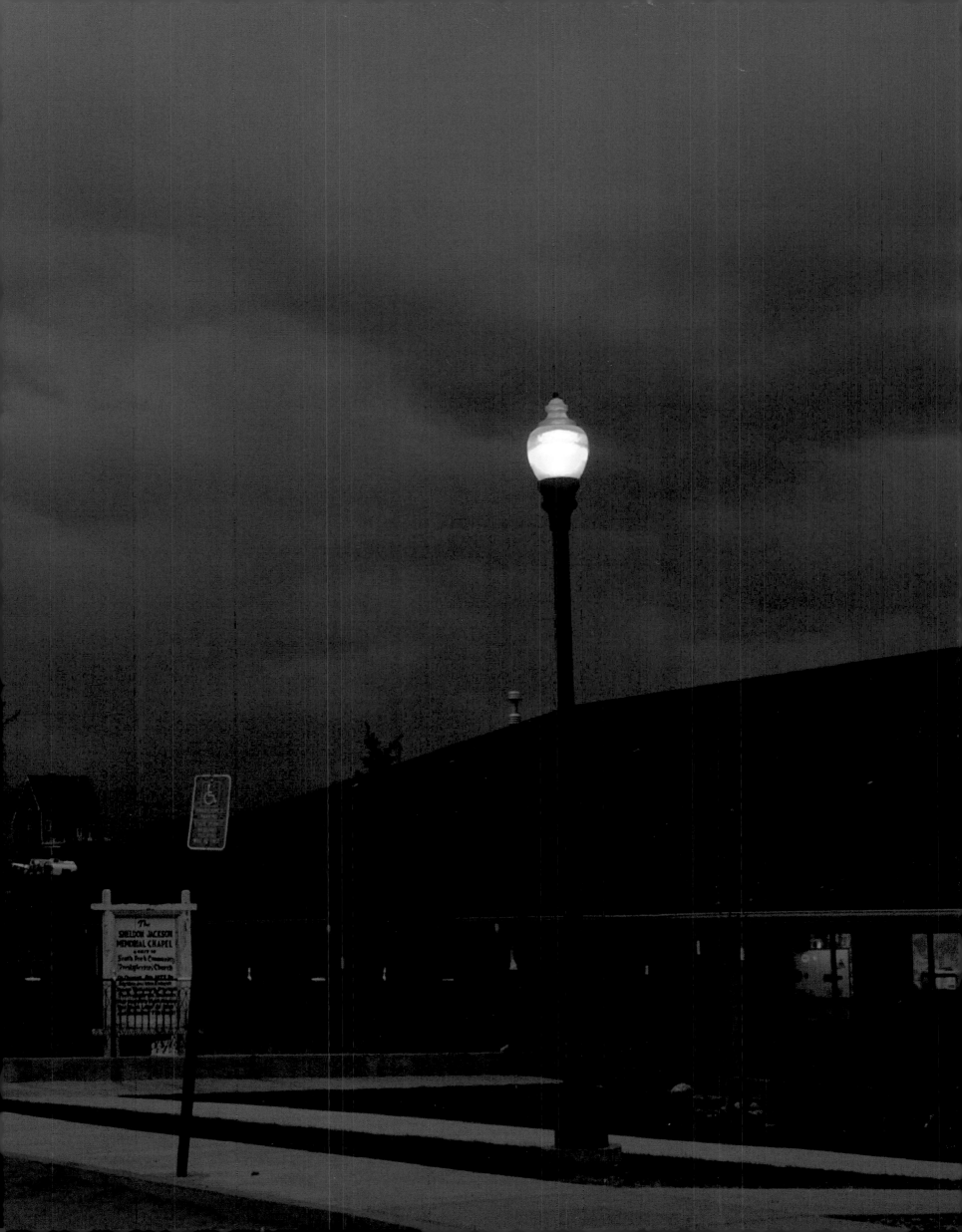

BOULDER
Don Allen, who prefers to be called "Moses,"
flashes a heartfelt message to pedestrians along
the Pearl Street Mall.
Photo by Jessica Maynard

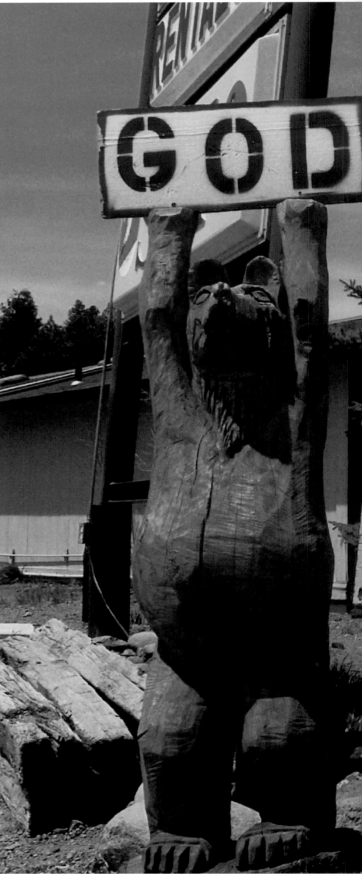

SOUTH FORK

A few years ago, Dusty Hicks, owner of Doc's Outdoor Sports, commissioned cowboy wood-carver Gordon Possien to create three bears for his shop. Hicks rotates these signs with others. Sometimes they're patriotic, sometimes they're promotional, and other times he just wants to make people smile—that's when he puts Don't Shoot signs in the bears' paws.
Photo by Larry C. Price

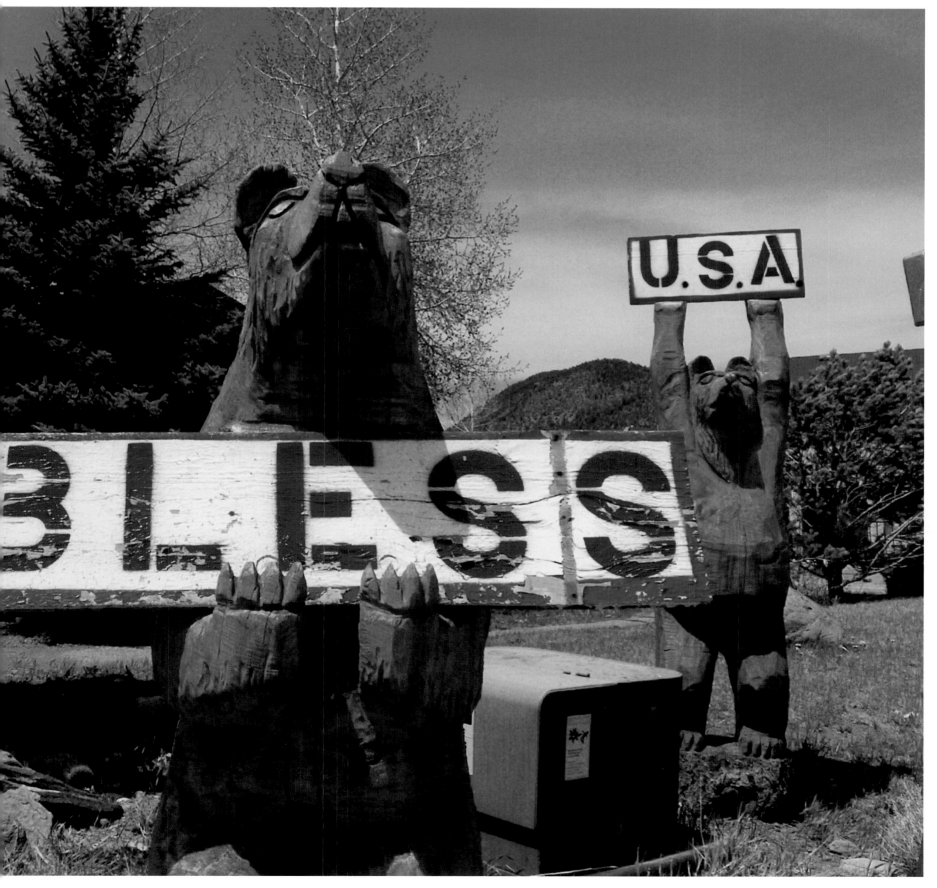

AURORA

Let the sun shine in: Sanaa Shaikh soaks up some rays floating down from the huge skylight at the Islamic Center during Friday worship service. Run by the Colorado Muslim Society, the center is home to the largest mosque in Colorado.
Photo by Barry Gutierrez, Rocky Mountain News

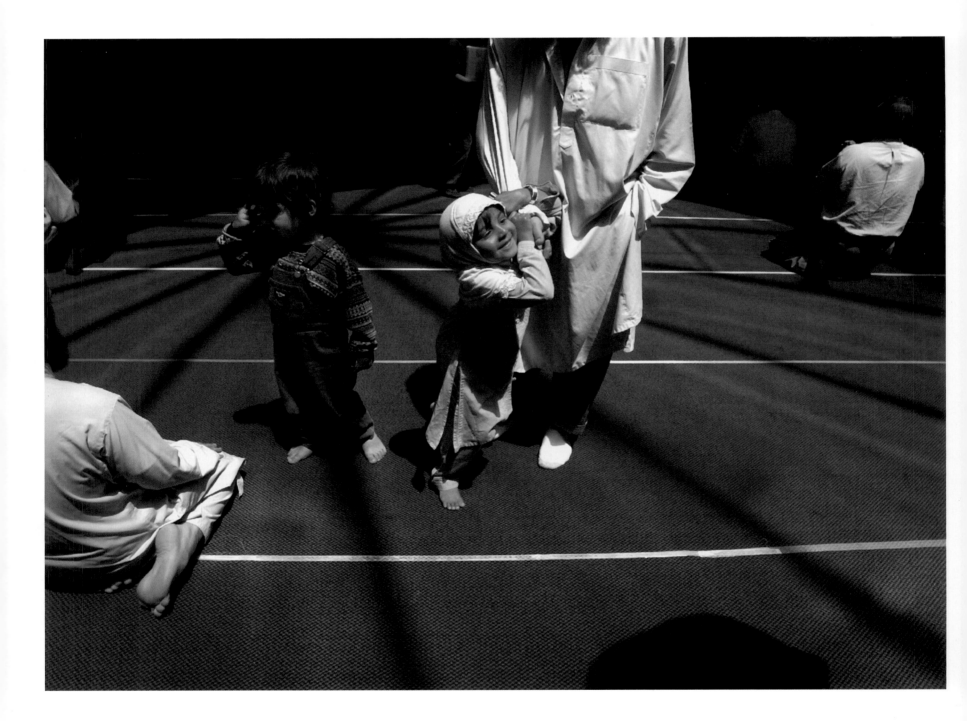

DENVER

Walled in by two slabs of black marble, the Box Car Bridge aims to re-create the experience of Russian Jews who were transported to concentration camps in cattle cars. The monument is part of Babi Yar Park and is dedicated to the 200,000 Jews executed by the Nazis in a ravine called Babi Yar, outside of Kiev, Ukraine.
Photo by Craig F. Walker, The Denver Post

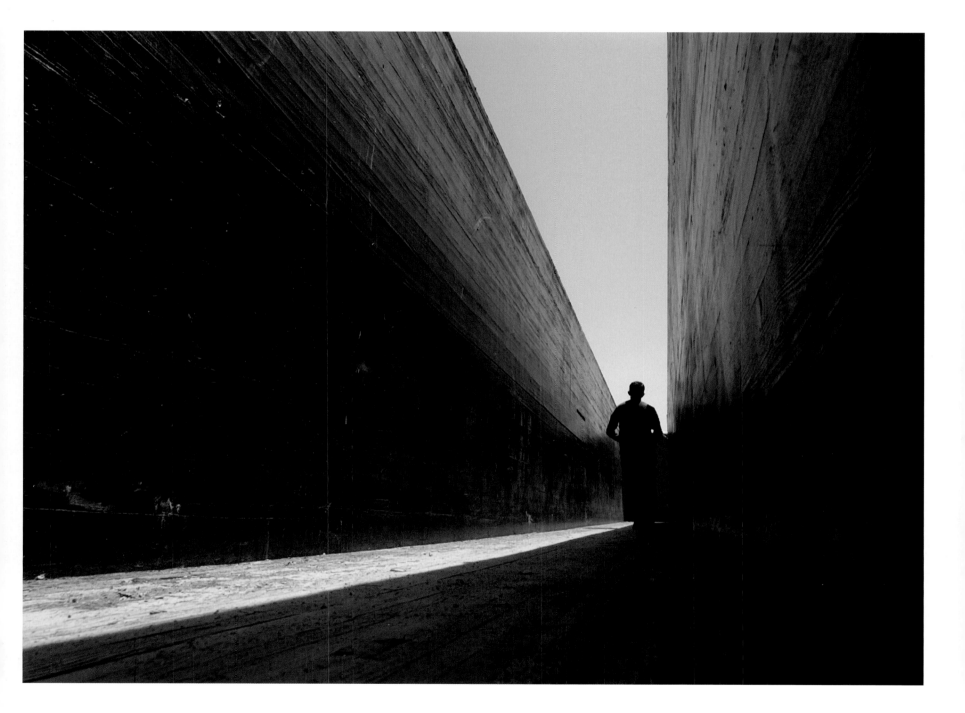

GRANADA
Reverend Kanya Okamoto presides over a service at Camp Amache, as Michiko Tashiro, 70, prays in front of a memorial altar. The camp barracks were home to Tashiro and her family from 1942–1945, when they were interned by executive order of President Franklin Roosevelt, who commanded the relocation of all Japanese Americans inland from the West Coast.
Photo by Glenn J. Asakawa, The Denver Post

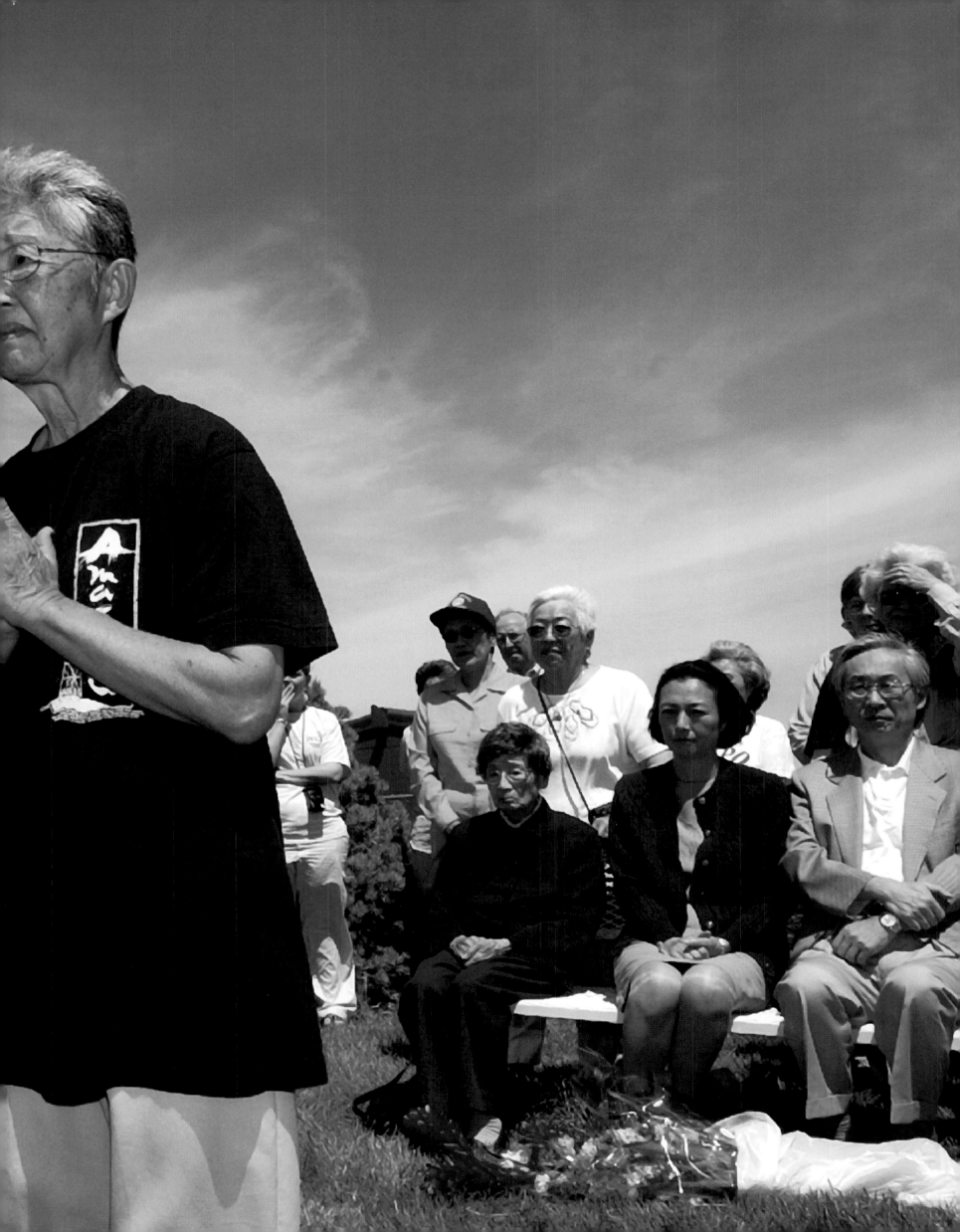

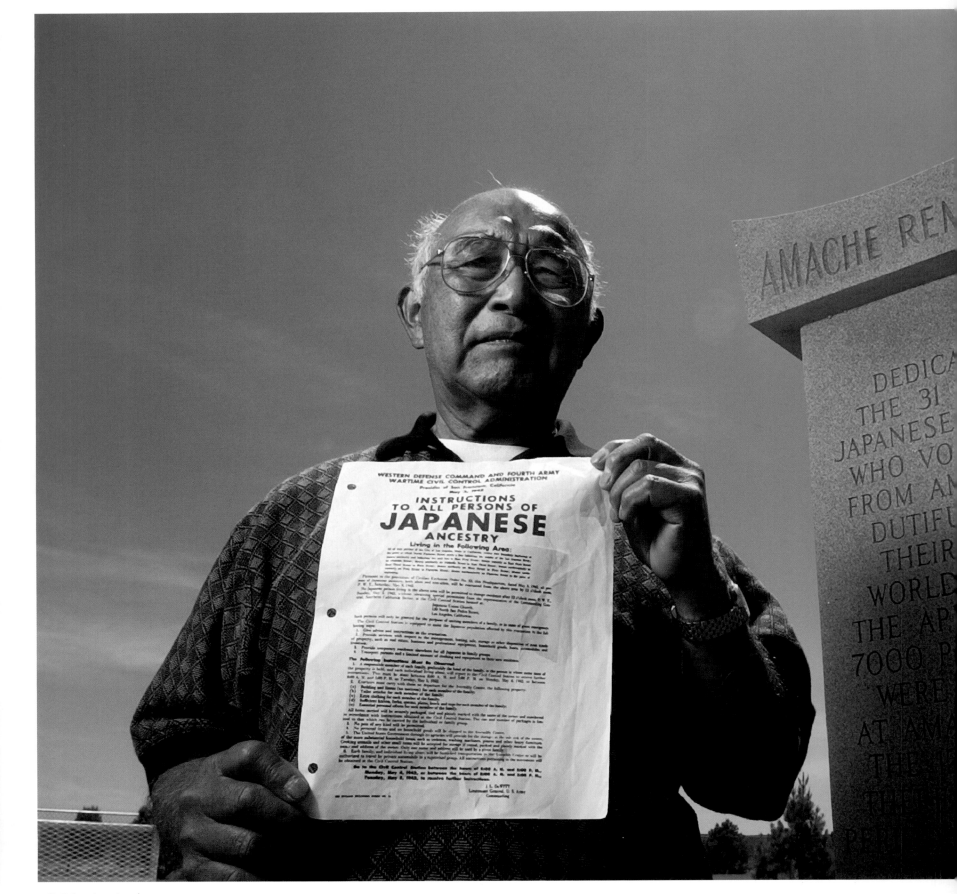

GRANADA

When an internment notice arrived at the Tashiro rice farm near Modesto, California, Frank Tashiro, now 76, was 13 years old. The family—all United States citizens—only had two weeks before they were shipped to 10,500-acre Camp Amache in Granada. Ten percent of the young men at Camp Amache volunteered for military service, joining units like the highly decorated 442nd Regimental Combat Team.

Photos by Glenn J. Asakawa, The Denver Post

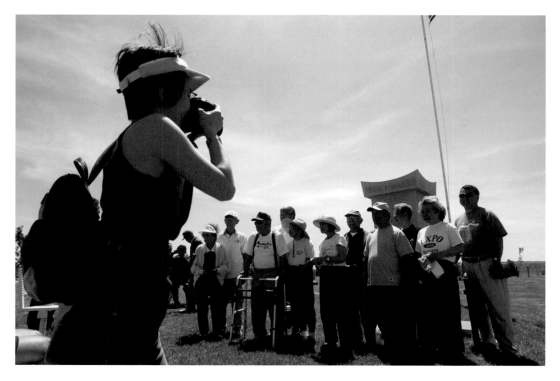

GRANADA

Joanne Tashiro takes a photo of camp survivors after a memorial service at Camp Amache. She accompanied dad Frank, and his three siblings—Michiko, Lucille, and Hideyo, all now California residents—on a pilgrimage to their war-time home. The eleven-member Tashiro family lived in two 24x40-feet rooms. "It's important for children to see what we went through," says Frank.

GRANADA

Michiko Tashiro sells copies of *From Our Side of the Fence* during a four-hour bus ride from Denver to Camp Amache. The collection of stories by Tashiro and 10 other camp survivors was developed in a workshop. During its three-year lifespan, the camp's population reached 7,567—making it Colorado's tenth-largest city at the time.

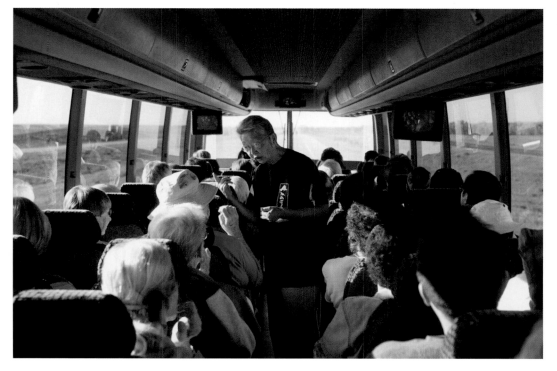

FAIRPLAY

Hand Hotel, built in 1931 by the Hand family, has five permanent residents. According to Mayor Tammy Quinn, paranormal investigators have confirmed that the hotel is indeed haunted by the following ghosts: a broken-hearted outlaw, a prostitute, Grandma Hand, and two little girls who were victims of a 1920s smallpox epidemic.
Photo by Carl Scofield

BROOMFIELD
Suburban Broomfield County, newly created in 2001, is one of several counties along Colorado's Front Range growing at a furious rate. One reason is the high-tech firms that have relocated to the area. The downside: increased traffic, smog, and overburdened transit systems; and bleak, cookie-cutter communities like Rock Creek.
Photo by Peter Lockley

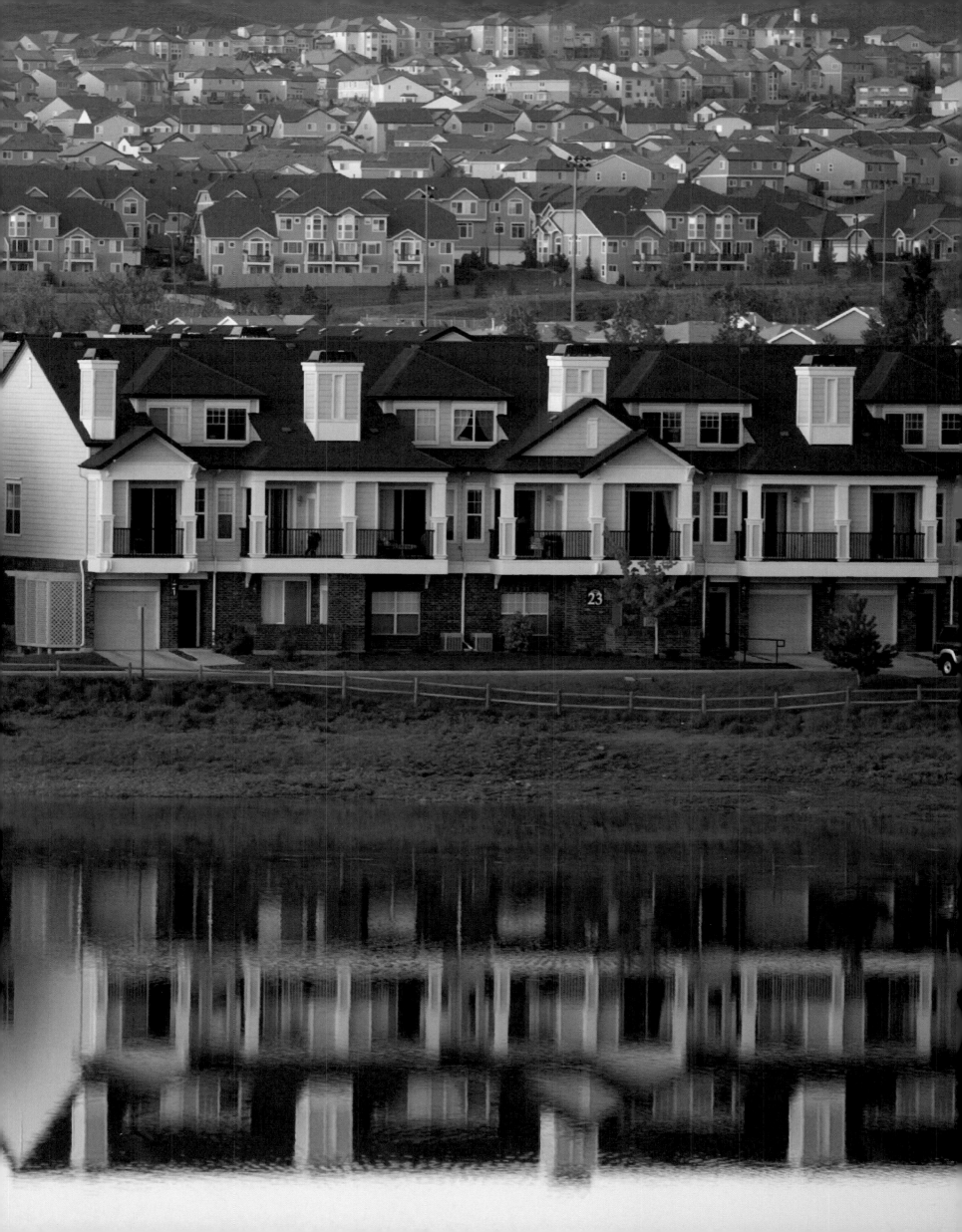

ERIE
Long's Peak, the tallest mountain in Rocky
Mountain National Park, towers above a
farmhouse in Erie, 15 miles east of Boulder.
Photo by Barry Gutierrez,
Rocky Mountain News

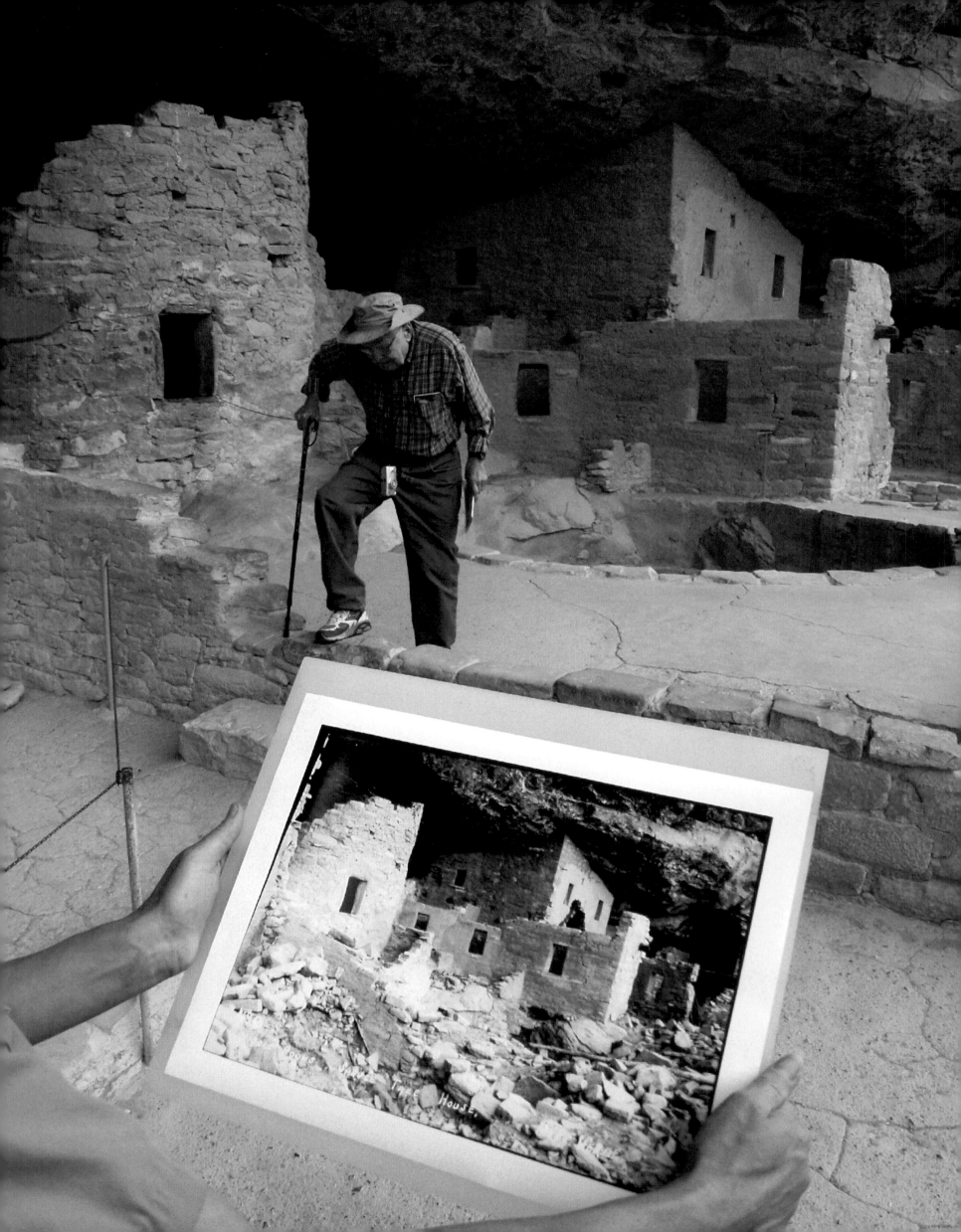

MESA VERDE

Mesa Verde National Park archaeologist Kay Barnett compares a 1902 photograph of the Spruce Tree House Cliff Dwelling with today's site. The 850-year-old settlement, sheltered under an 89-foot overhang and built into the side of a 216-foot-long cave, is one of the best preserved ancestral Puebloan sites in America.

Photo by Jay Dickman

MANCOS

Started in 1959, Mud Creek Hogan Trading Post sells Native American arts and crafts. Owners Bill and Judy Countess decided to install the giant arrows (made from telephone poles) seventeen years ago. "It was simply an attention getter and it sure does work," says Judy. Most visitors come from nearby Mesa Verde National Park and the Four Corners area.

Photo by Larry C. Price

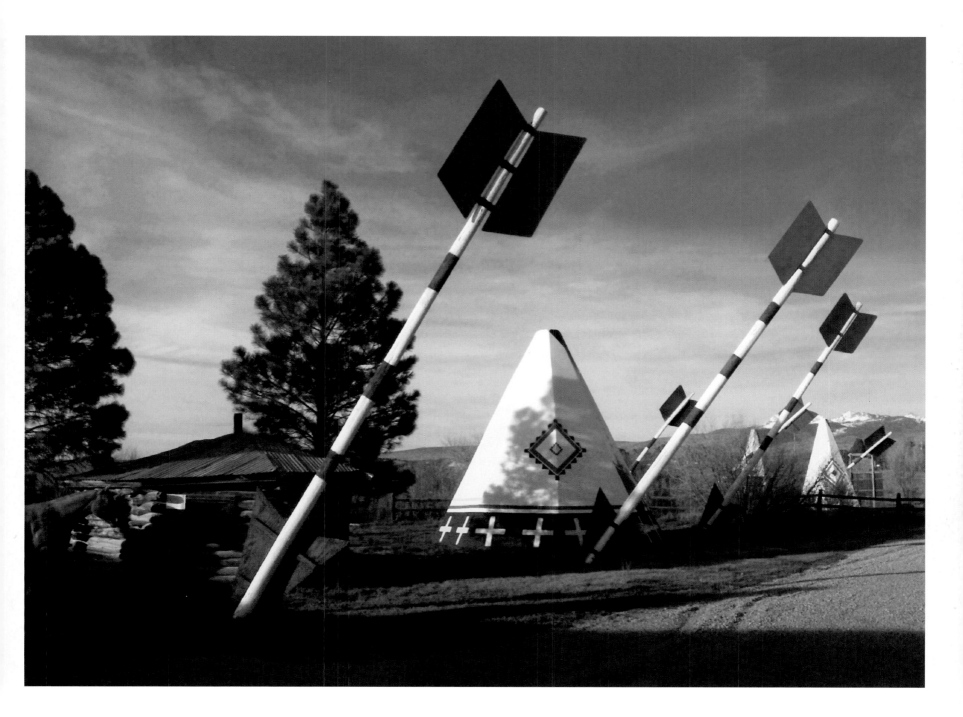

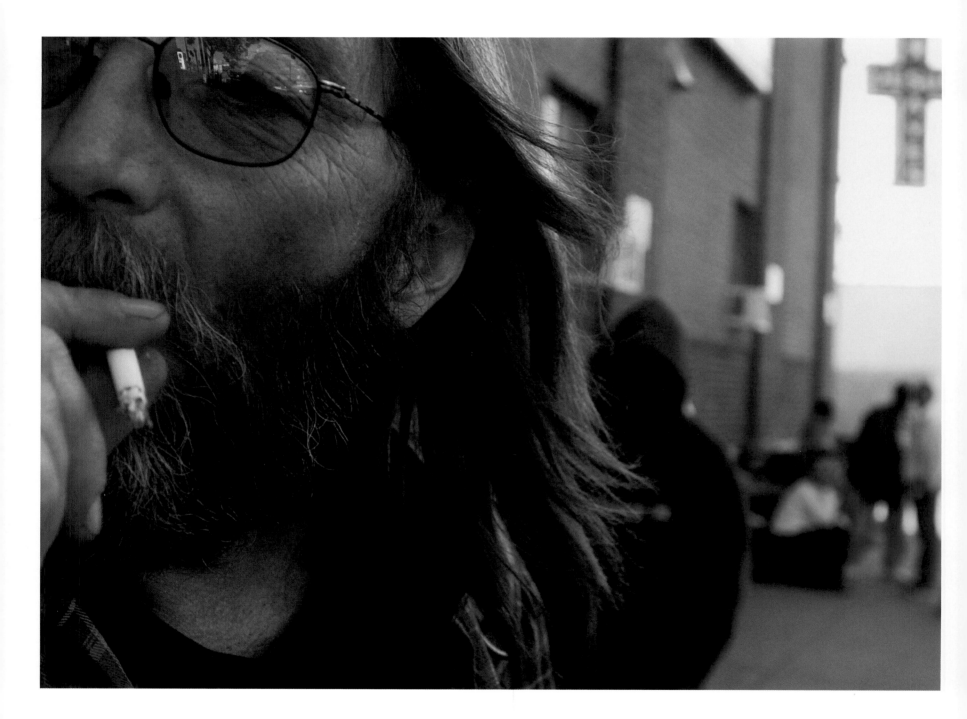

DENVER
Forty percent of the city's homeless residents, like Calvin Adai, are employed; he works three days a week as a landscaper. The former mill operator lost his full-time job almost two years ago and, without a steady income to pay his rent, was forced to seek nightly shelter at the Denver Rescue Mission.
Photo by Craig F. Walker, The Denver Post

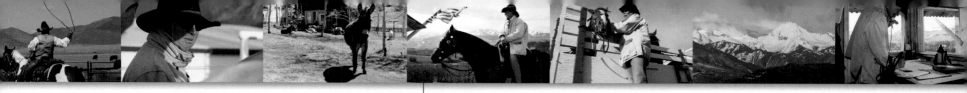

TELLURIDE

In 1970, Roudy Roudebush came to Telluride from Wisconsin to see the Rockies. After pounding nails and tending bar, he started an outfitter business in 1984 called Telluride Horseback Adventures. He says, "I got gentle horses for gentle people. Fast horses for fast people. And for people that don't like to ride, I got horses that don't like to be rode."
Photo by Robert Millman

COLORADO SPRINGS
The Air Force Academy Academic Library staircase is the only means of transit for freshman cadets. The elevators are off limits. This 142,000-square-foot monument to information houses 500,000 books and one million government documents, along with 1,600 periodicals.
Photo by Mark Reis,
The Colorado Springs Gazette

DENVER
Three concentric circles of walkways orbit the Colorado State Capitol building's gilded dome built in 1908.
Photo by Craig F. Walker, The Denver Post

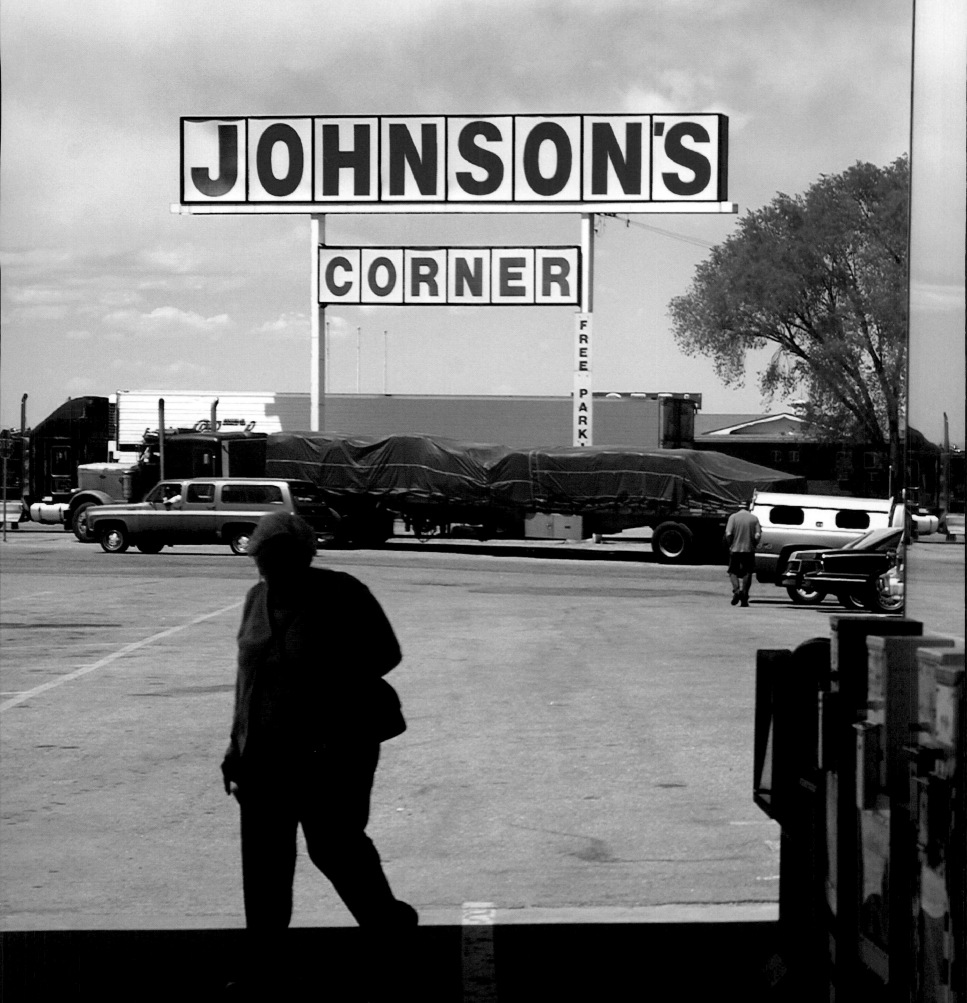

LOVELAND
Farmers, truckers, and tourists commingle
at Johnson's Corner 24-hour diner and truck
stop made famous in 1998 when *Travel +
Leisure* magazine named it one of the top
ten breakfast spots in the world. The menu
item that won the editors over: Johnson's

MONTROSE

Richard Olsen and buddy Mike Robb unwind after a three-day Cowboy Action Shooting match. This fast-growing sport is a form of Wild West fantasy gunfighting. Using three types of late 19th century firearms—a pistol, a lever-action rifle, and a double-barrel shotgun—each contestant moves through 12 scenarios that test speed and accuracy.

Photo by Robert Millman

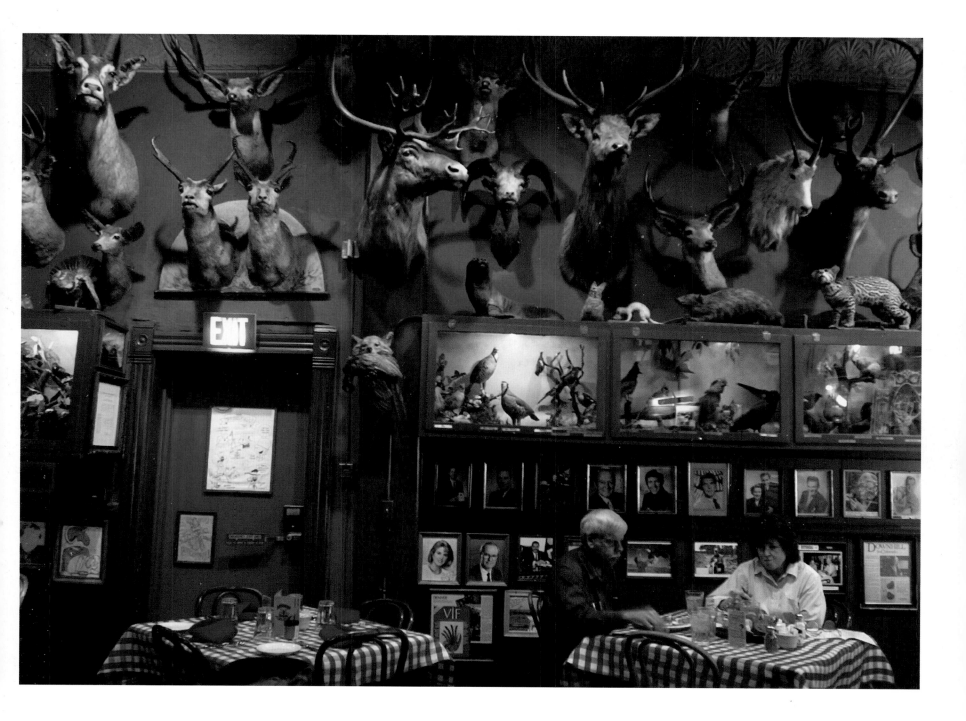

DENVER

After riding as a scout with Buffalo Bill Cody, Henry H. Zietz—or Shorty Scout as he was nicknamed by Sitting Bull—opened the Buckhorn Exchange restaurant in 1893. That was the same year he nailed down Colorado's first liquor license. More than 100 years later, tourists Dale and Ginger Ware dig into a steak lunch under Buckhorn trophy heads.

Photo by Glenn J. Asakawa, The Denver Post

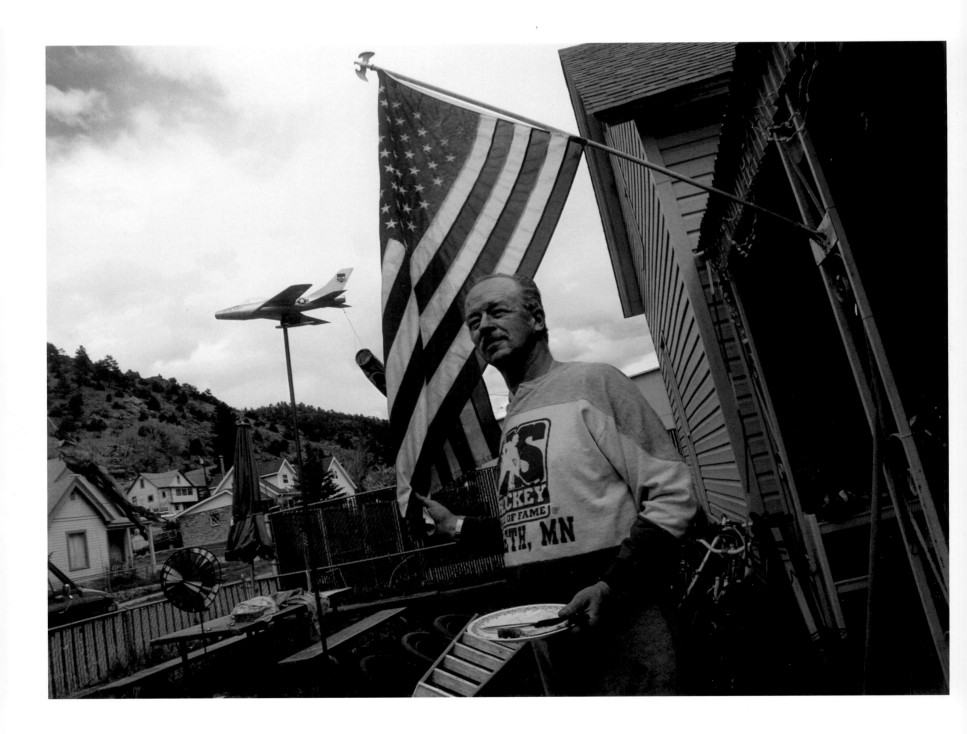

IDAHO SPRINGS

"This is the best country there is," says electrician Eugene Eddy. "Sure it's got problems, but we have to take care of it." The F-100 model plane with a POW MIA windsock hanging from its tail shows Eddy's support for the troops—he was an F-100 crew chief in Vietnam.

Photo by Emily Yates-Doerr

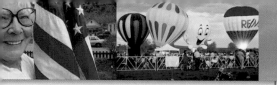

COLORADO SPRINGS

Professional skydiver Ralph Williams opens the "In Their Honor Air Show" on Armed Forces Day weekend with a spectacular flag display. Don't try this at home, though: Williams, a veteran of 500 jumps, has to pull seven levers at just the right moment and then parachute 2,500 feet with the fully extended 70-pound flag.

Photo by Mark Reis, The Colorado Springs Gazette

GUNNISON COUNTY
Commercial sheep ford a snow-fed stream near the Gunnison National Forest. Colorado ranchers graze livestock on federal lands under the Federal Grazing Program—a controversial permit system that critics say leads to the destruction of protected habitats and biodiversity. Ranchers say livestock fertilizes and improves the health of public rangelands.
Photo by Todd Heisler, Rocky Mountain News

DEL NORTE
Utah and Cayenne never stray far from their owner's Ford pick-up. The pups were found starving under a bridge two years ago by Jamie Gage who loaded them into the bed of her truck, took them home, and nursed them back to health.
Photo by Michael S. Lewis

GENOA
Rocks, bizarre biological offerings, and a two-headed goat are just the tip of the eye-popping iceberg at the Tower Museum in Genoa, about 100 miles east of Denver.
Photo by Neal Ulevich

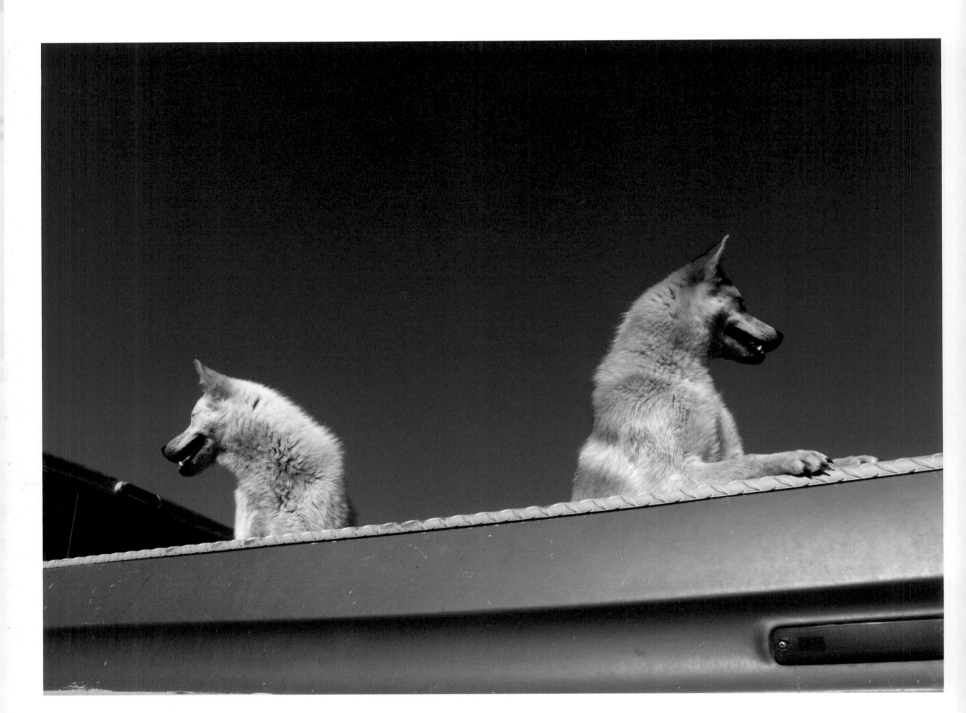

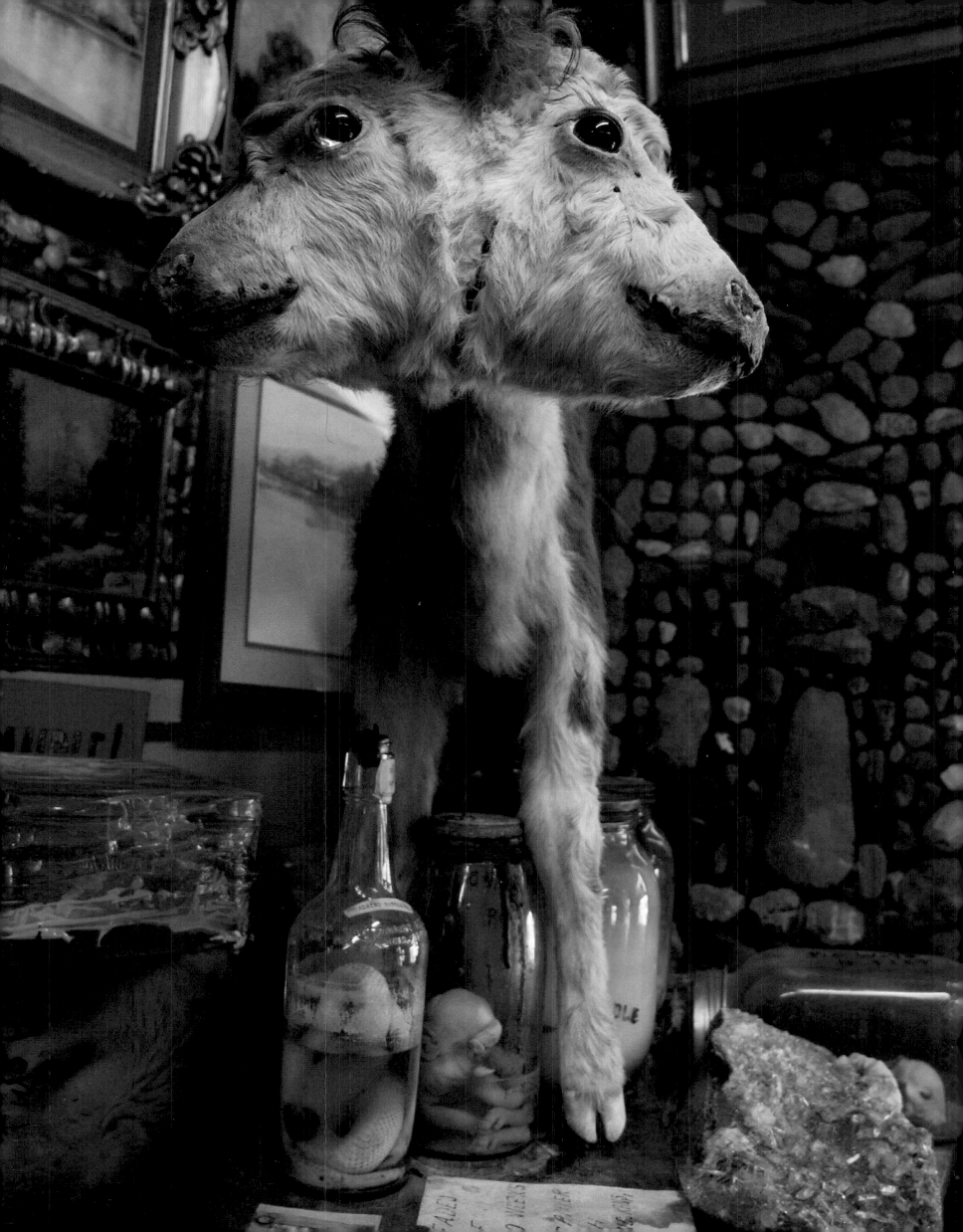

MORRISON

Red Rocks rocks: A sold-out crowd packs the world-renowned amphitheatre for Big Head Todd and the Monsters. A geologically formed, open-air amphitheatre not duplicated anywhere in the world, Red Rocks consists of two, 300-foot monoliths (Ship Rock and Creation Rock, both red sandstone) that provide acoustic perfection.
Photo by Peter Lockley

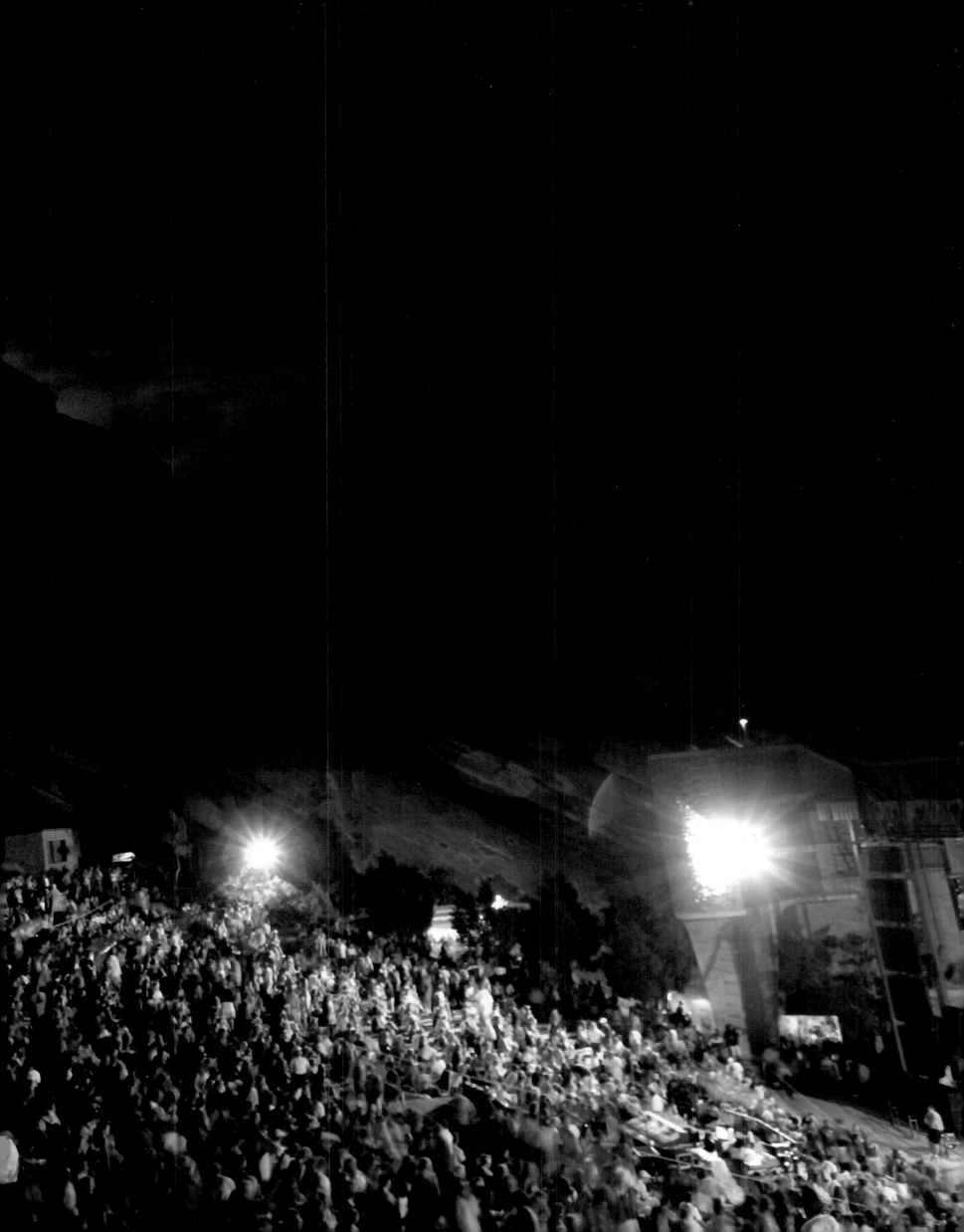

GENOA
Arrowheads screen a window in the narrow, winding display hall at the Tower Museum.
Photo by Neal Ulevich

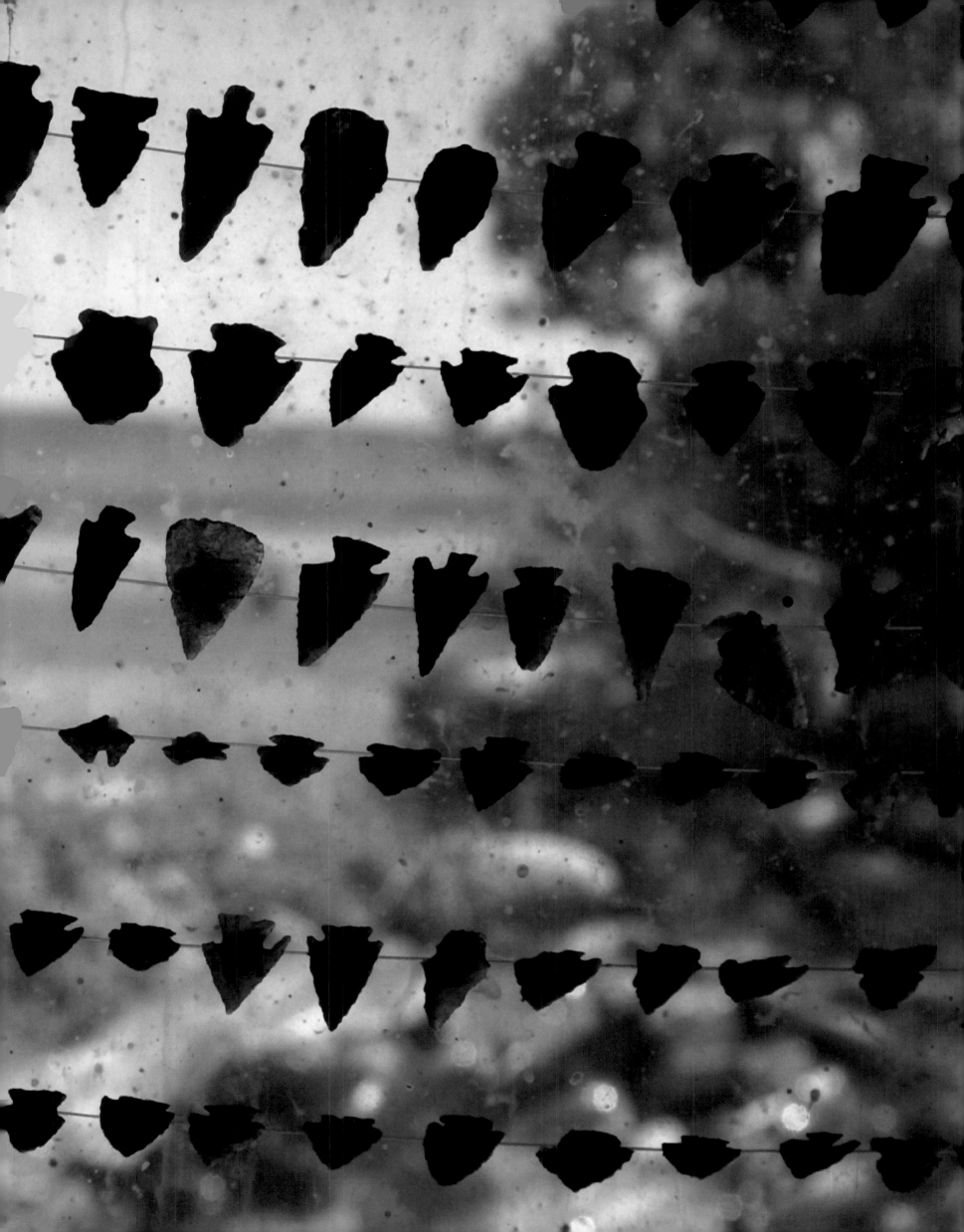

GLENWOOD SPRINGS
An approaching storm silhouettes a ridge of trees, remnants of the 2002 Coal Seam Fire, which burned 12,000 acres, destroyed 29 homes, and forced the evacuation of 3,000 people. The blaze was started by an underground coal seam that had been smoldering for almost 100 years.
Photo by Robert Millman

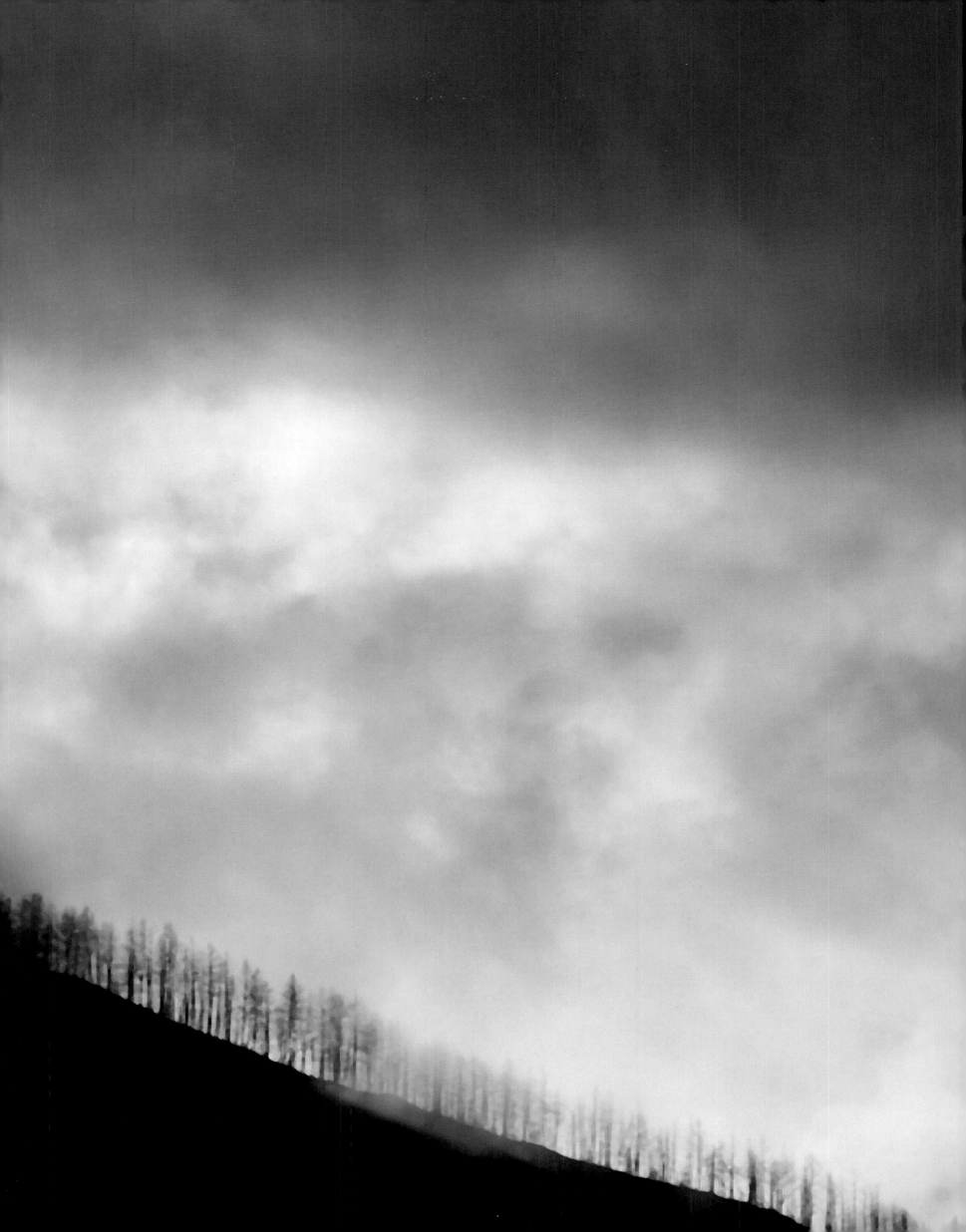

How It Worked

The week of May 12-18, 2003, more than 25,000 professional and amateur photographers spread out across the nation to shoot over a million digital photographs with the goal of capturing the essence of daily life in America.

The professional photographers were equipped with Adobe Photoshop and Adobe Album software, Olympus C-5050 digital cameras, and Lexar Media's high-speed compact flash cards.

The 1,000 professional contract photographers plus another 5,000 stringers and students sent their images via FTP (file transfer protocol) directly to the *America 24/7* website. Meanwhile, thousands of amateur photographers uploaded their images to Snapfish's servers.

At *America 24/7*'s Mission Control headquarters, located at CNET in San Francisco, dozens of picture editors from the nation's most prestigious publications culled the images down to 25,000 of the very best, using Photo Mechanic by Camera Bits. These photos were transferred into Webware's ActiveMedia Digital Asset Management (DAM) system, which served as a central image library and enabled the designers to track, search, distribute, and reformat the images for the creation of the 51 books, foreign language editions, web and magazine syndication, posters, and exhibitions.

Once in the DAM, images were optimized (and in some cases resampled to increase image resolution) using Adobe Photoshop. Adobe InDesign and Adobe InCopy were used to design and produce the 51 books, which were edited and reviewed in multiple locations around the world in the form of Adobe Acrobat PDFs. Epson Stylus printers were used for photo proofing and to produce large-format images for exhibitions. The companies providing support for the *America 24/7* project offer many of the essential components for anyone building a digital darkroom. We encourage you to read more on the following pages about their respective roles in making *America 24/7* possible.

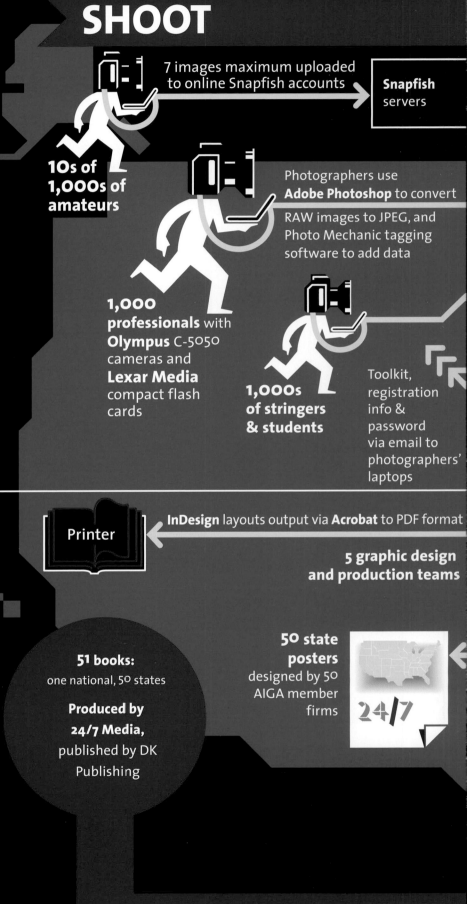

SHOOT

7 images maximum uploaded to online Snapfish accounts

Snapfish servers

10s of 1,000s of amateurs

Photographers use **Adobe Photoshop** to convert RAW images to JPEG, and Photo Mechanic tagging software to add data

1,000 professionals with **Olympus** C-5050 cameras and **Lexar Media** compact flash cards

1,000s of stringers & students

Toolkit, registration info & password via email to photographers' laptops

InDesign layouts output via **Acrobat** to PDF format

Printer

5 graphic design and production teams

51 books: one national, 50 states

Produced by 24/7 Media, published by DK Publishing

50 state posters designed by 50 AIGA member firms

24/7

DESIGN & PUBLISH

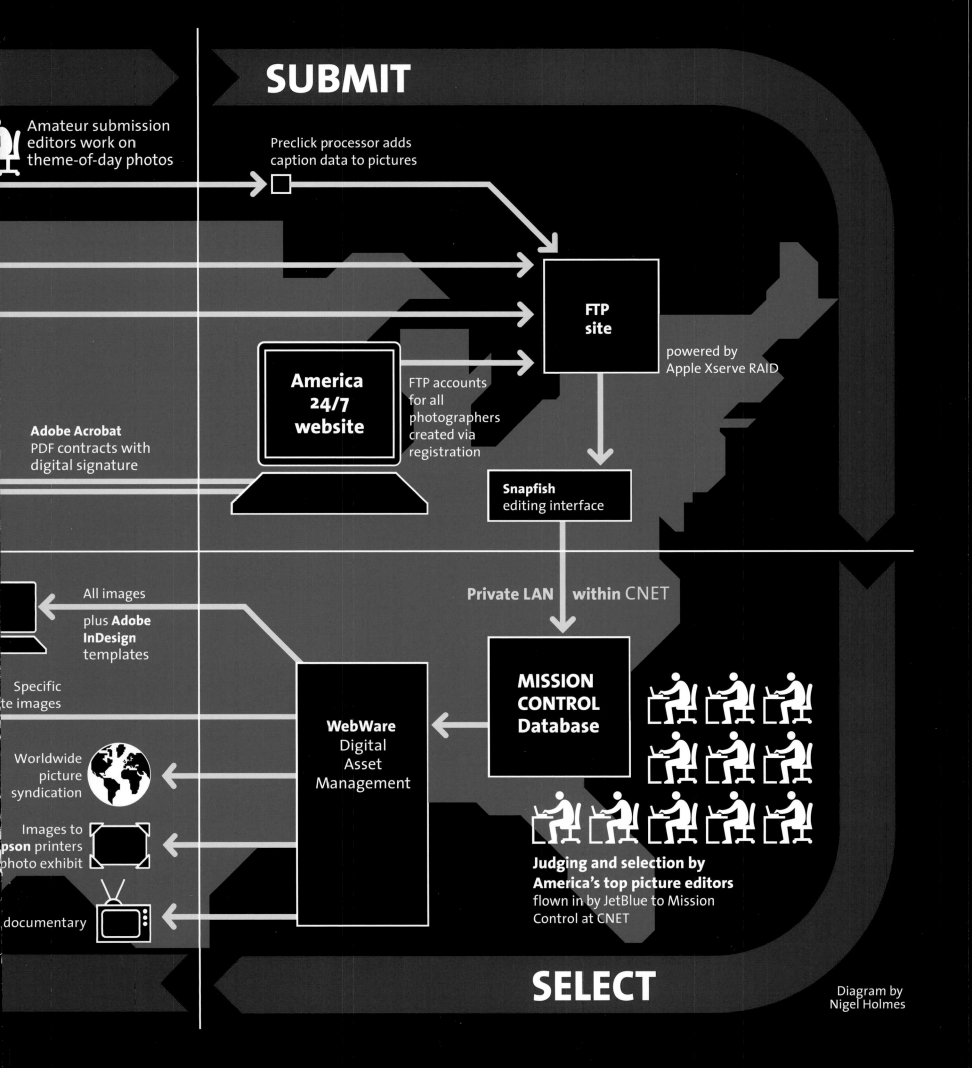

SUBMIT

Amateur submission editors work on theme-of-day photos

Preclick processor adds caption data to pictures

FTP site

powered by Apple Xserve RAID

America 24/7 website

FTP accounts for all photographers created via registration

Adobe Acrobat PDF contracts with digital signature

Snapfish editing interface

All images

plus **Adobe InDesign** templates

Private LAN within CNET

Specific te images

WebWare Digital Asset Management

MISSION CONTROL Database

Worldwide picture syndication

Images to pson printers photo exhibit

documentary

Judging and selection by America's top picture editors flown in by JetBlue to Mission Control at CNET

SELECT

Diagram by Nigel Holmes

Staff

The *America 24/7* series was imagined years ago by our friend Oscar Dystel, a publishing legend whose vision and enthusiasm have been a source of great inspiration.

We also wish to express our gratitude to our truly visionary publisher, DK.

Rick Smolan, Project Director
David Elliot Cohen, Project Director

Administrative
Katya Able, Operations Director
Gina Privitere, Communications Director
Chuck Gathard, Technology Director
Kim Shannon, Photographer Relations Director
Erin O'Connor, Photographer Relations Intern
Leslie Hunter, Partnership Director
Annie Polk, Publicity Manager
John McAlester, Website Manager
Alex Notides, Office Manager
C. Thomas Hardin, State Photography Coordinator

Design
Brad Zucroff, Creative Director
Karen Mullarkey, Photography Director
Judy Zimola, Production Manager
David Simoni, Production Designer
Mary Dias, Production Designer
Heidi Madison, Associate Picture Editor
Don McCartney, Production Designer
Diane Dempsey Murray, Production Designer
Jan Rogers, Associate Picture Editor
Bill Shore, Production Designer and Image Artist
Larry Nighswander, Senior Picture Editor
Bill Marr, Sarah Leen, Senior Picture Editors
Peter Truskier, Workflow Consultant
Jim Birkenseer, Workflow Consultant

Editorial
Maggie Canon, Managing Editor
Curt Sanburn, Senior Editor
Teresa L. Trego, Production Editor
Lea Aschkenas, Writer
Olivia Boler, Writer
Korey Capozza, Writer
Beverly Hanly, Writer
Bridgett Novak, Writer
Alison Owings, Writer
Fred Raker, Writer
Joe Wolff, Writer
Elise O'Keefe, Copy Chief
Daisy Hernández, Copy Editor
Jennifer Wolfe, Copy Editor

Infographic Design
Nigel Holmes

Literary Agent
Carol Mann, The Carol Mann Agency

Legal Counsel
Barry Reder, Coblentz, Patch, Duffy & Bass, LLP
Phil Feldman, Coblentz, Patch, Duffy & Bass, LLP
Gabe Perle, Ohlandt, Greeley, Ruggiero & Perle, LLP
Jon Hart, Dow, Lohnes & Albertson, PLLC
Mike Hays, Dow, Lohnes & Albertson, PLLC
Stephen Pollen, Warshaw Burstein, Cohen, Schlesinger & Kuh, LLP
Rick Pappas

Accounting and Finance
Rita Dulebohn, Accountant
Robert Powers, Calegari, Morris & Co. Accountants
Eugene Blumberg, Blumberg & Associates
Arthur Langhaus, KLS Professional Advisors Group, Inc.

Picture Editors
J. David Ake, Associated Press
Caren Alpert, formerly *Health* magazine
Simon Barnett, *Newsweek*
Caroline Couig, *San Jose Mercury News*
Mike Davis, formerly *National Geographic*
Michel duCille, *Washington Post*
Deborah Dragon, *Rolling Stone*
Victor Fisher, formerly Associated Press
Frank Folwell, *USA Today*
MaryAnne Golon, *Time*
Liz Grady, formerly *National Geographic*
Randall Greenwell, *San Francisco Chronicle*
C. Thomas Hardin, formerly *Louisville Courier-Journal*
Kathleen Hennessy, *San Francisco Chronicle*
Scot Jahn, *U.S. News & World Report*
Steve Jessmore, *Flint Journal*
John Kaplan, University of Florida
Kim Komenich, *San Francisco Chronicle*
Eliane Laffont, *Hachette Filipacchi Media*
Jean-Pierre Laffont, *Hachette Filipacchi Media*
Andrew Locke, MSNBC
Jose Lopez, *The New York Times*
Maria Mann, formerly AFP
Bill Marr, formerly *National Geographic*
Michele McNally, *Fortune*
James Merithew, *San Francisco Chronicle*
Eric Meskauskas, *New York Daily News*
Maddy Miller, *People* magazine
Michelle Molloy, *Newsweek*
Dolores Morrison, *New York Daily News*
Karen Mullarkey, formerly *Newsweek, Rolling Stone, Sports Illustrated*
Larry Nighswander, Ohio University School of Visual Communication
Jim Preston, *Baltimore Sun*
Sarah Rozen, formerly *Entertainment Weekly*
Mike Smith, *The New York Times*
Neal Ulevich, formerly Associated Press

Website and Digital Systems
Jeff Burchell, Applications Engineer

Television Documentary
Sandy Smolan, Producer/Director
Rick King, Producer/Director
Bill Medsker, Producer

Video News Release
Mike Cerre, Producer/Director

Digital Pond
Peter Hogg
Kris Knight
Roger Graham
Philip Bond
Frank De Pace
Lisa Li

Senior Advisors
Jennifer Erwitt, Strategic Advisor
Tom Walker, Creative Advisor
Megan Smith, Technology Advisor
Jon Kamen, Media and Partnership Advisor
Mark Greenberg, Partnership Advisor
Patti Richards, Publicity Advisor
Cotton Coulson, Mission Control Advisor

Executive Advisors
Sonia Land
George Craig
Carole Bidnick

Advisors
Chris Anderson
Samir Arora
Russell Brown
Craig Cline
Gayle Cline
Harlan Felt
George Fisher
Phillip Moffitt
Clement Mok
Laureen Seeger
Richard Saul Wurman

DK Publishing
Bill Barry
Joanna Bull
Therese Burke
Sarah Coltman
Christopher Davis
Todd Fries
Dick Heffernan
Jay Henry
Stuart Jackman
Stephanie Jackson
Chuck Lang
Sharon Lucas
Cathy Melnicki
Nicola Munro
Eunice Paterson
Andrew Welham

Colourscan
Jimmy Tsao
Eddie Chia
Richard Law
Josephine Yam
Paul Koh
Chee Cheng Yeong
Dan Kang

Chief Morale Officer
Goose, the dog

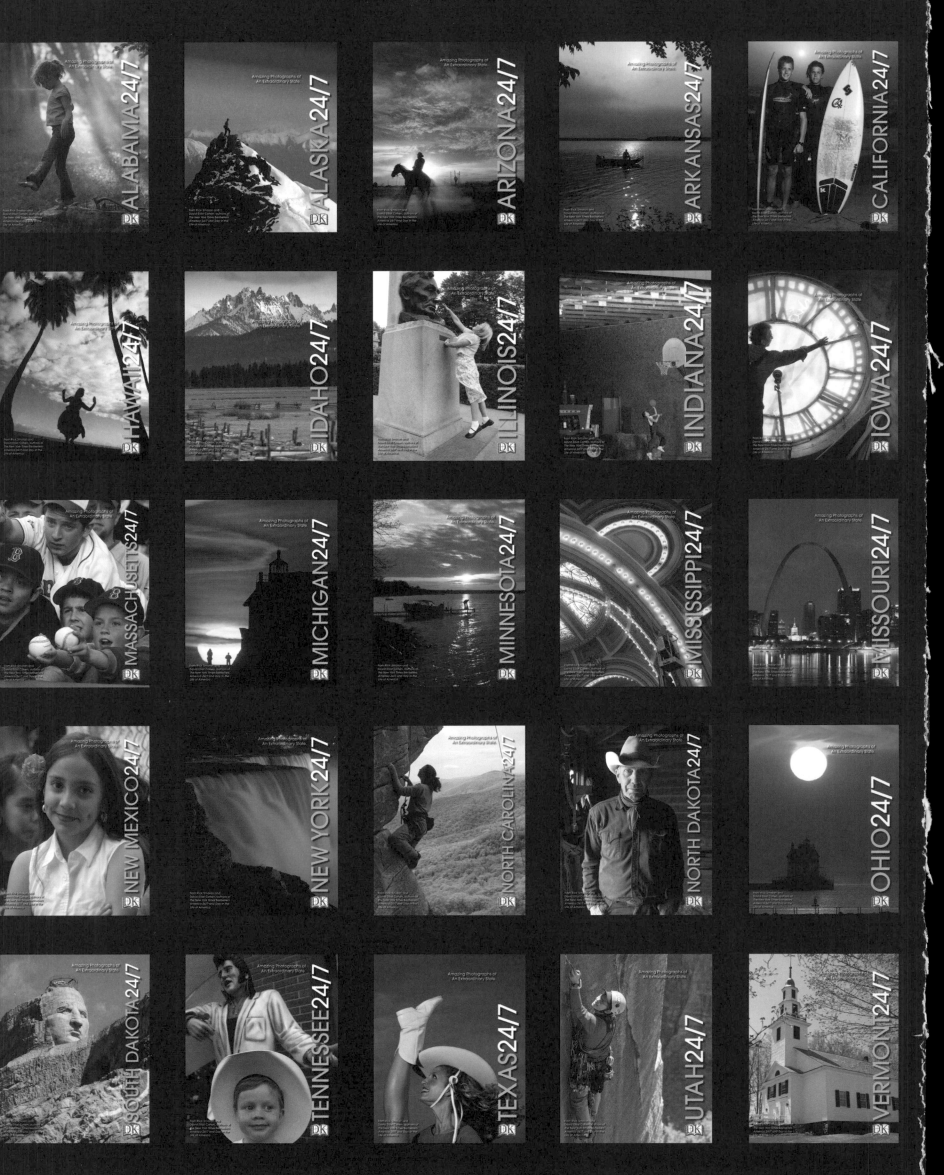